Watercolour for Absolute Beginners

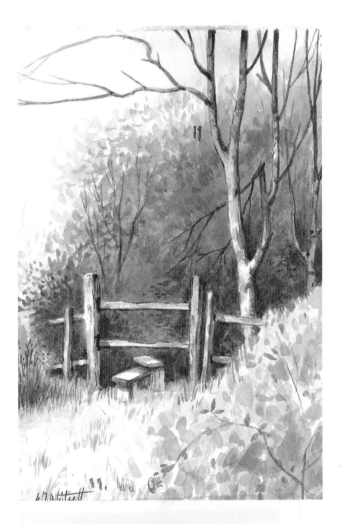

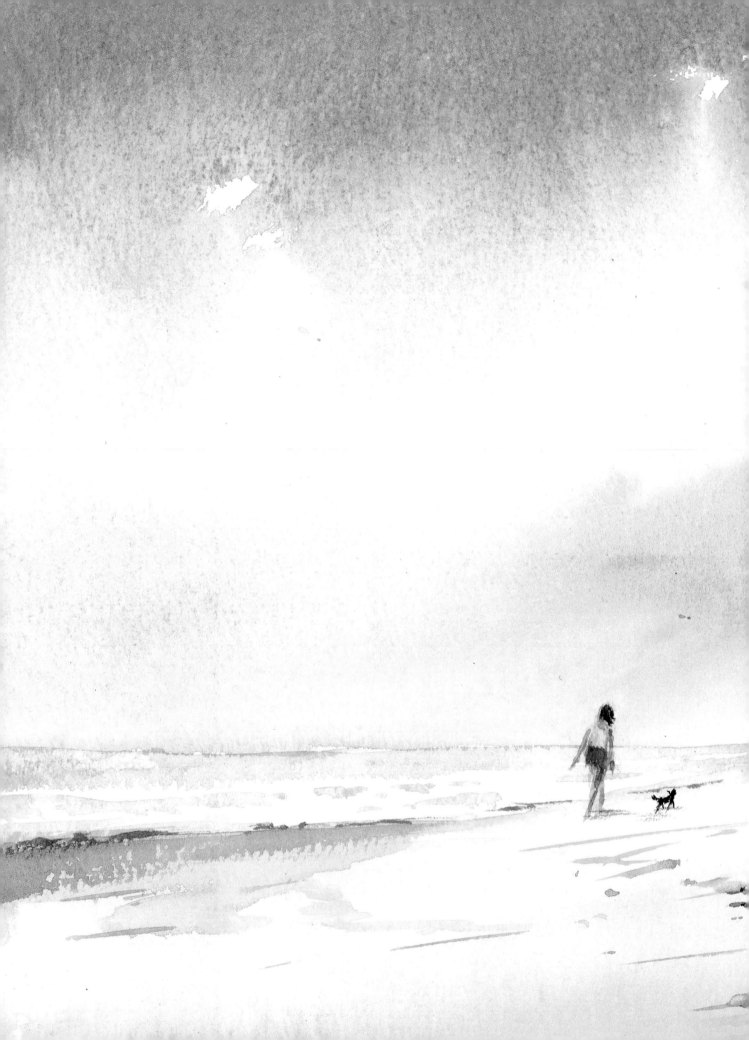

Watercolour for Absolute Beginners

Bill Whitsett
& Nancy Cadorette

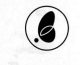

B T Batsford

First published 2003
Reprinted 2004
This paperback edition published 2005

Images © Bill Whitsett 2003, 2005
Text © Bill Whitsett and Nancy Cadorette 2003, 2005

ISBN 0 7134 8929 4

A CIP catalogue record for this book is available from the
British Library.

Designed by Zeta Jones
Printed in Singapore by Kyodo Printing Co. Ltd

for the publishers

B T Batsford
Chrysalis Books Group
The Chrysalis Building
Bramley Road
London W10 6SP

www.chrysalisbooks.co.uk

An imprint of **Chrysalis** Books Group plc

Distributed in the United States and Canada by Sterling Publishing Co.,
387 Park Avenue South, New York, NY 10016, USA

Contents

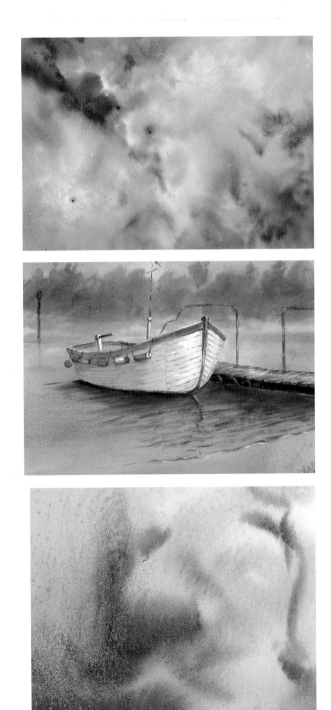

This book is dedicated to my wonderful family and all the students who have made my years of teaching art a happy and fulfilling career.

Acknowledgements

Without the help of Nancy Cadorette, my editor and partner in this effort, this book could not have been developed. She somehow managed to make sense of my notes and put them into a manageable form. I would also like to thank Jane Donovan, senior editor at Chrysalis Books, for her gentle guidance in the early development of this book. I would especially like to thank my wife Babs, whose support and patience throughout this endeavour deserves a gold medal!

Bill Whitsett

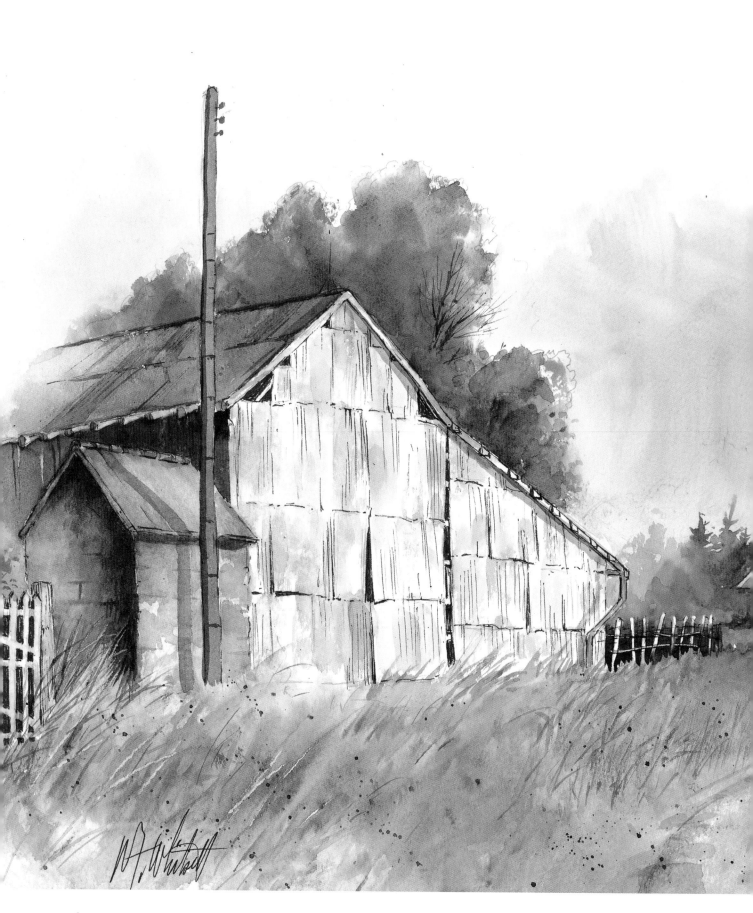

Above *This painting was done from a detailed drawing that I did while in Normandy.*

Save your drawings – you may be able to use them to compose a painting.

Introduction

This book is written with the hope that it will help beginners as well as more advanced students enjoy the marvellous medium of watercolour. I am a professional teacher who is mad about painting – perhaps in this book I can communicate some of my enthusiasm to you. Painting is not only concerned with producing pictures, it is a way of life. How often have I heard beginners say, 'Until I started painting with watercolour, I had never looked closely at skies or trees or flowers. Painting has changed my life!' It is a vehicle for happiness, but to find this enjoyment you must be prepared to dedicate yourself to the observation of nature and be willing to learn through countless attempts at mastering the medium. You will find yourself part of an ever-increasing circle as you meet other artists, go to exhibitions, read more books about art, watch more art programmes on television and spend more time drawing. You will be joining a community of like-minded people, all trying to express their feelings about the exciting world of colour all around us. It is my privilege to help guide you through this endeavour. All the best!

Please understand that this book is aimed at helping you, as a beginner or intermediate student, gain control of watercolour. In the long run, however, if you are to become a competent artist, it will also ultimately become an individual and creative search for expression – a process unique to each of us.

Sincerely,

Bill Whitsett

Chapter I

Getting Started

Before we can begin, you will need to get some
supplies. Be careful: beginners often fail because
they are using materials of such poor quality that they
cannot possibly succeed. Whenever possible, try to get the
supplies that I have recommended.

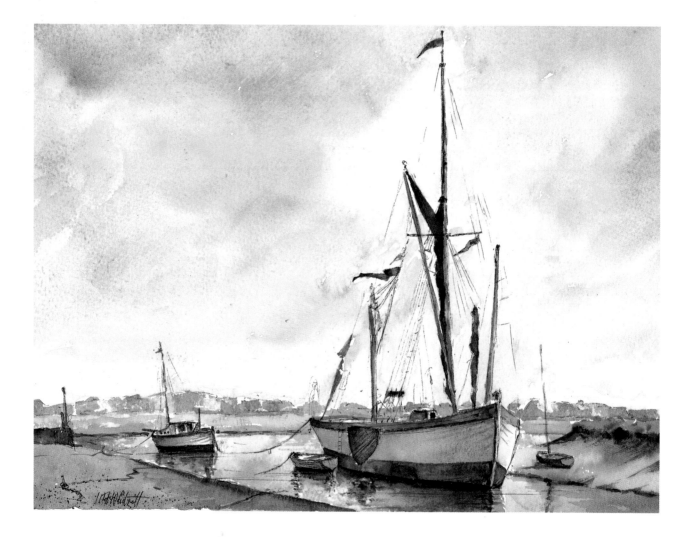

Watercolour Paints

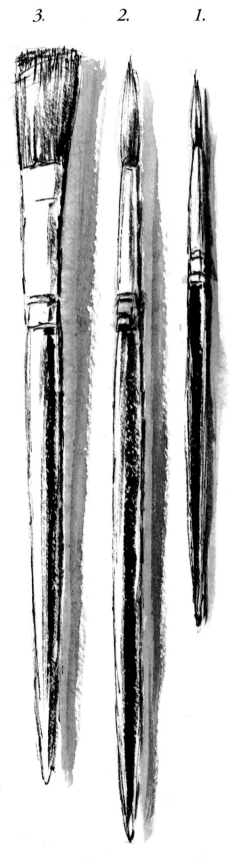

3. 2. 1.

Try to get artist-grade paints, such as Winsor & Newton, Grumbacher or Rembrandt. Poorer quality paints have less pigment and more filler, so it takes more paint to get the same results. This can also cause the colour of the paint to be slightly 'off'.

The colours I have used in these exercises – which are also those I usually use when I paint – are as follows:

- Winsor red
- Alizarin crimson
- Cadmium yellow light (or pale)
- Yellow ochre
- Burnt sienna
- Burnt umber
- Viridian
- Ultramarine
- Prussian blue
- Payne's grey
- Ivory black

Watercolour Brushes

If possible, buy the best-quality watercolour brushes. Poor-quality brushes may not hold their shape or hold much water, so they can be very difficult to use.

You'll need three different brushes for these exercises. Most companies use the same system for numbering their brushes, but because a few do not, I have included a sketch showing the approximate size and shape of each brush.

1. Round brush, number 3. This will be used to paint details, so it needs to be able to hold a point.
2. Round brush, number 8. This will be used for general work.
3. Flat brush, 2.5cm (1in). This will be used for large areas such as skies.

Palette

I recommend palettes that have both wells to hold the paint and flat areas on which to mix it.

If you have a permanent arrangement of colours on the palette, it will make it easier for you to locate them. Below is a suggested plan that groups the warm colours on one side and the cool colours separately.

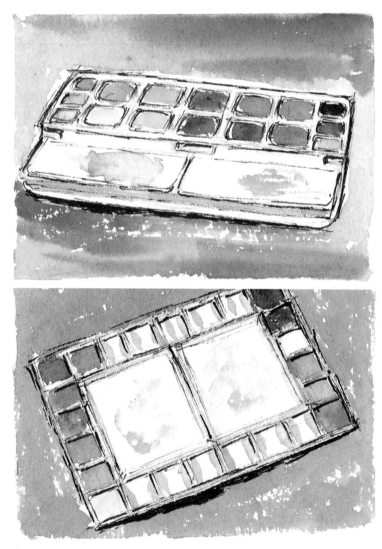

Warm colours:
Yellow ochre, Winsor red, burnt sienna, burnt umber, cadmium yellow light

Cool colours:
Prussian blue, ultramarine, viridian, Payne's grey, ivory black

You would be wise to fill the wells and continue to keep your paints in the order described above so you won't have to struggle to find the colour you want. After painting, clean the mixing areas of your palette, but not the paint wells. Let the paint dry in the wells so that by simply moistening them you will be ready to start again next time.

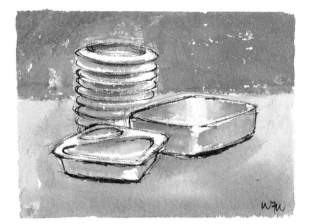

Water Containers

You'll need two containers for water. Use one container for rinsing and cleaning paint out of your brush and the other for getting clean water on the brush – this is important to avoid muddying your colours.

Paper and easel

It is very important that you use paper made for watercolour painting. For these exercises use 'Not' watercolour paper, which is neither too smooth nor too rough. In the United States it is called 'cold pressed' watercolour paper. The paper should be 300gsm (140 pound) and 28 × 38cm (11 × 15in). There are many brands – I suggest you use Bockingford if you live in the United Kingdom or Canson if you live in the United States. There are many that are of the same or better quality, but these will work fine for my exercises, and you should be able to find them in almost any art supply store.

You'll need a roll of 1.3cm (¹/₂in) masking tape. This will be used to keep the paper from buckling when it is wet.

The easiest way to work is with an adjustable table easel, but you could also place your board in your lap and lean it on a table.

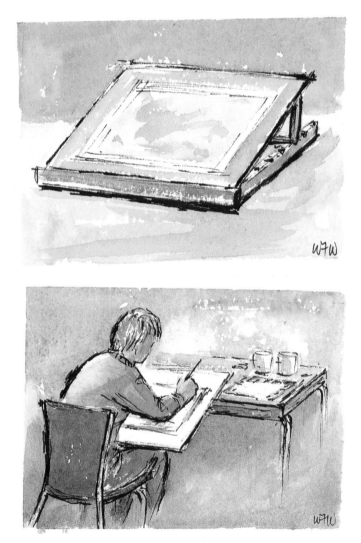

Miscellaneous Items

It's also useful to have the following items on hand:

- Pencil (preferably HB) for drawing lightly on the watercolour paper
- Rubber (eraser)
- Small sponge
- Tissues
- Ruler
- Drawing board (unless you are using a pad of prestretched watercolour paper).

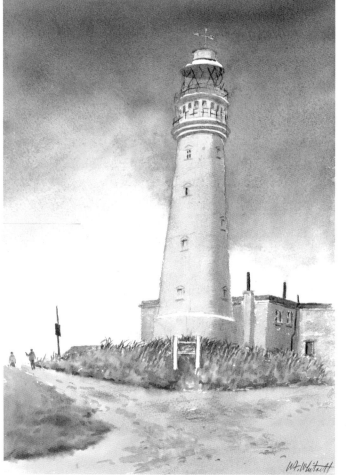

Left *The lighthouse provides a dramatic silhouette as well as contrast with the small figures. The figures help to give us a sense of scale.*

Setting up your Work Area

1. Tape the watercolour paper onto your drawing board using masking tape. Tape down all four edges to prevent the paper from buckling when it is wet. (You do not need to do this if you are using a pad of prestretched paper.)

2. If your paints are dry, sprinkle some water on them so they will not be too hard when you use them.

3. Arrange your work area so that everything is easy to find. Remove anything that is not needed for watercolour painting.

4. For most lessons, tilt up your paper to an angle of 20°.

5. Read – then re-read – the instructions for each lesson before beginning.

6. Think slowly about what you are about to do before painting. When you are ready:
 • Dip your brush into clean water
 • Mix your colour on the palette
 • Paint in a positive manner (try not to 'fiddle' with your effort)

7. If you are not satisfied with what you have painted, you can usually remove it with a slightly moist sponge.

8. Don't get discouraged. It takes practice to master any new skill.

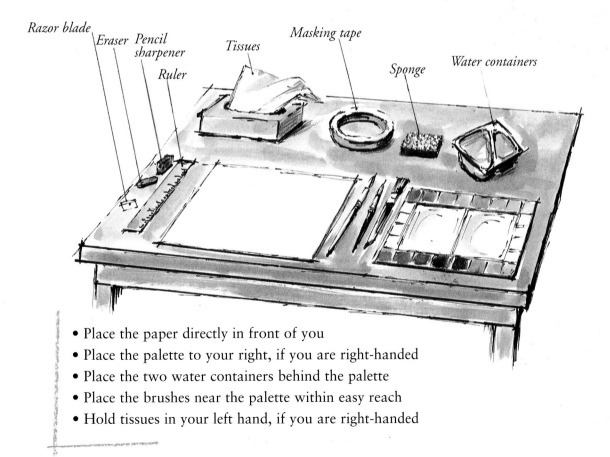

Razor blade Eraser Pencil sharpener Ruler Tissues Masking tape Sponge Water containers

• Place the paper directly in front of you
• Place the palette to your right, if you are right-handed
• Place the two water containers behind the palette
• Place the brushes near the palette within easy reach
• Hold tissues in your left hand, if you are right-handed

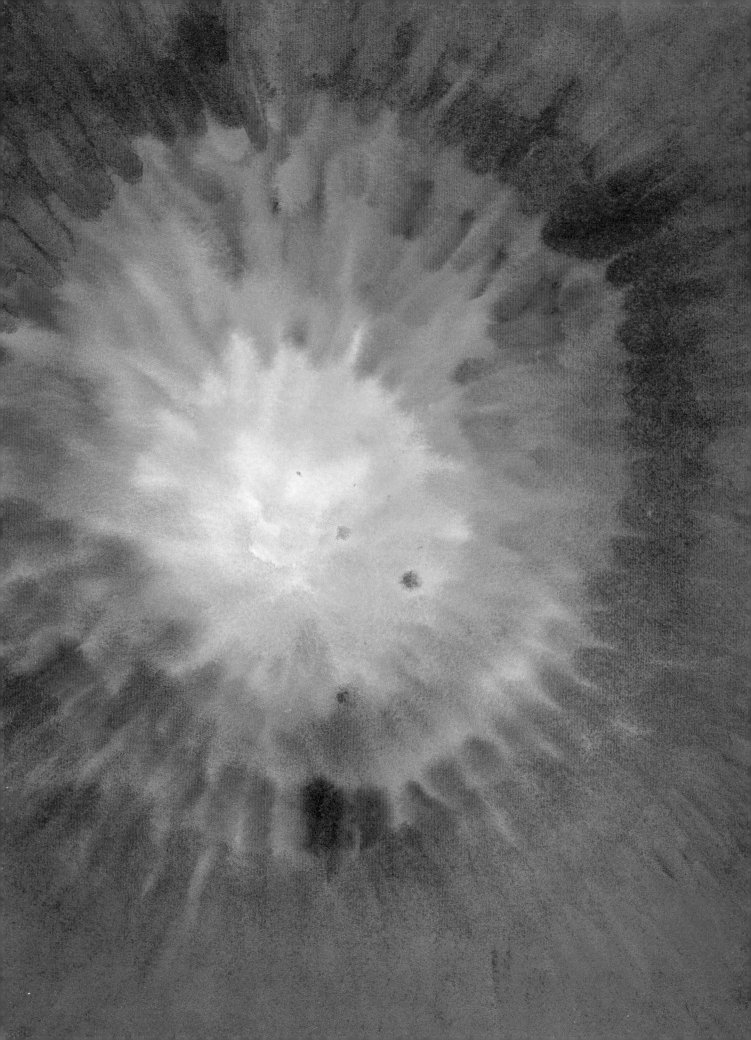

Colour is Exciting!

Let's learn the universal 'language of colour'. Its alphabet is very simple: red, yellow and blue. These are called the primary colours. All colours can be created by mixing these three colours together. Let me show you how.

Primary Colours

Draw three rectangles in the centre of your paper just as I've shown you (right). Then paint them in with alizarin crimson (red), cadmium yellow light and Prussian blue. Try to match the colours in my example.

Primary means that red, yellow and blue are original colours and cannot be made by mixing other colours together. (The specific hues used in colour printing – the so-called 'true primaries' – are known as process yellow, cyan and magenta.)

Secondary Colours

When you mix two primary colours together, you create a secondary colour. Add three more rectangles to your paper as shown in my example (right), then mix each of the secondary colours and paint them in.

- Create orange by mixing cadmium yellow light and Winsor red
- Create green by mixing cadmium yellow light and ultramarine
- Create violet by mixing alizarin crimson and ultramarine

Tertiary Colours

A tertiary colour is made by mixing a secondary colour with one of its constituent primary colours, making an extended range of hues. For example, you can create a tertiary colour by using any one of these colour combinations:

- Yellow and green
- Yellow and orange
- Red and orange
- Red and violet
- Blue and violet
- Blue and green

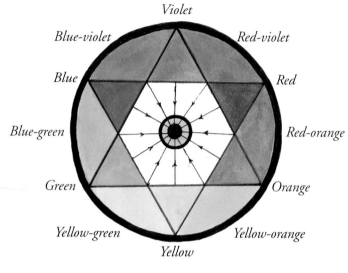

Complementary Colours

The colour wheel is an idea that helps to clarify the relationships between colours. Secondary colours are found midway between the primaries that were mixed to make them, while those that are located opposite each other on the colour wheel are called complementary colours. Some examples of complementary colours are:

- Red and green
- Blue and orange
- Yellow and violet

When complementary colours are mixed together, they create 'greys' (see diagram below). Many students believe that the word 'grey' means a shade of neutral 'battleship grey'. This is not true. When complementary colours are mixed together, they create at least 144 different colours that are all called 'grey' that don't look anything like battleship grey – or each other.

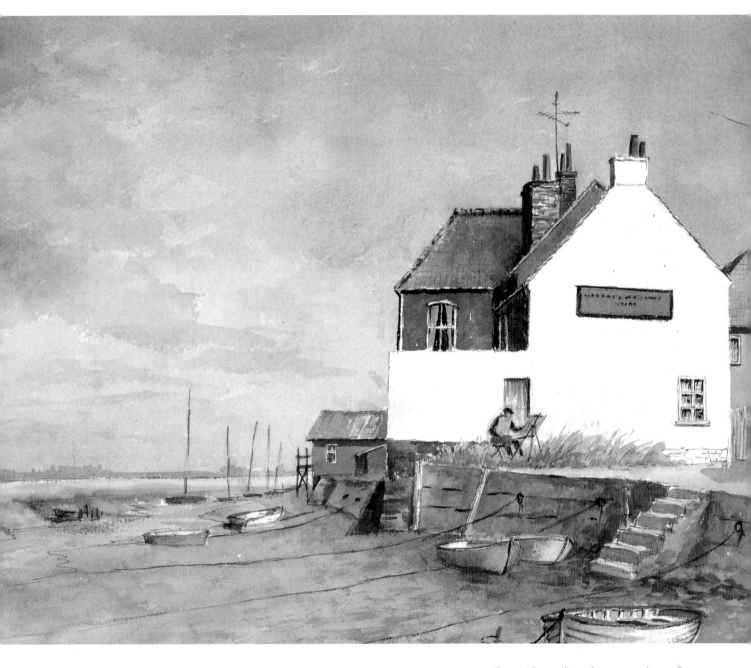

Above *Observe how the warm colours of the building and foreground contrast with the complementary blues of the water and the sky in this painting.*

What Makes up a Colour?

Colour has three properties: value (or tone), hue and chroma.

Value or Tone

Value, also known as tone, describes how light or dark a colour is. Some colours are naturally light in value as they come out of the tube, such as yellow. Others are dark as they come out of the tube, such as ultramarine. You can make colours lighter by adding water.

It is important to learn how to control the value of a colour. It is often the value differences that allow us to see things. Imagine a white bird in a thick snowstorm. It would be hard to see the bird because there is very little contrast (difference in value) between the bird and the snow.

Using ivory black, create a value scale (right) with the lightest value at the top and the darkest value at the bottom. Try to make nine different values. You may have to repeat this exercise a few times before you can create nine truly distinct values.

Create another value scale using one of your blues. Again, try to make nine different values.

1

2

3

4

5

6

7

8

9

Left *Close colour value relationships shown in a circle. It is important that we create more colour contrast in our paintings.*

Opposite page *I created the soft, misty mood in this painting by wetting the entire page before beginning to paint. This is a monochromatic painting, done with only one colour, Payne's grey.*

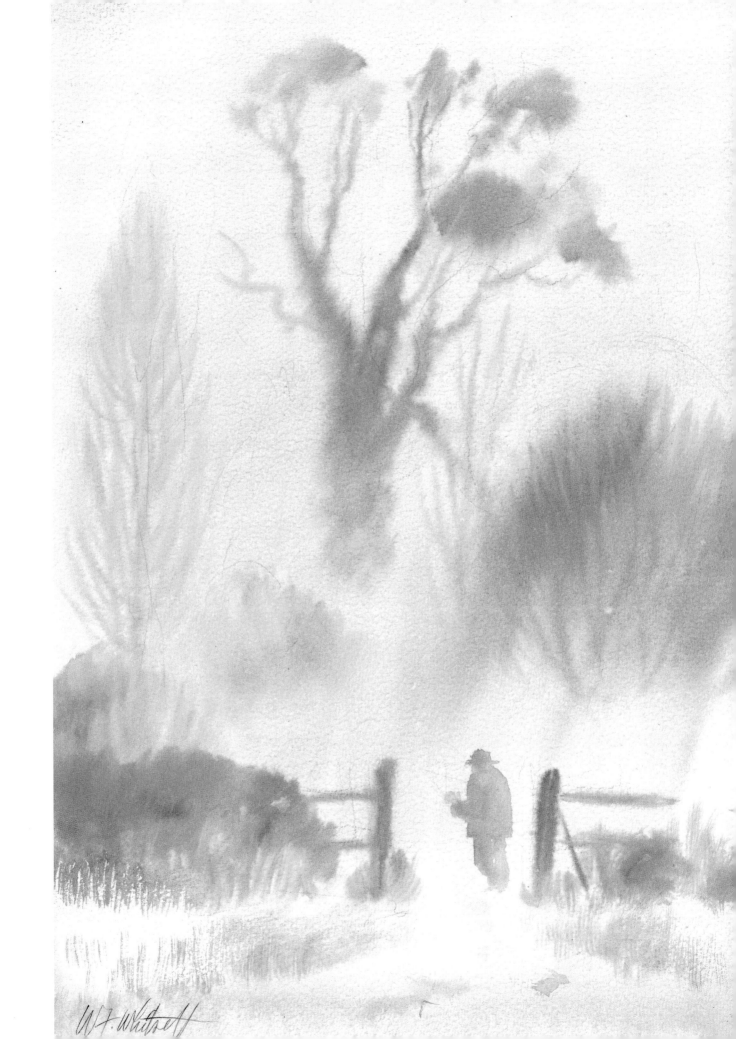

W.F. Whitsell

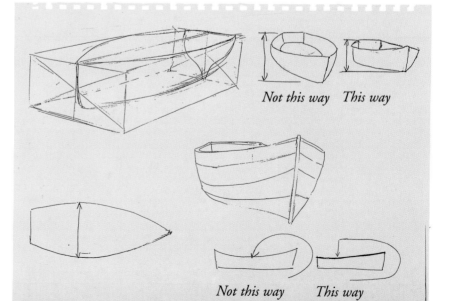

Above *Observe the amount of gradation of value and hue in this painting. Gradation tends to make every area of a painting more interesting.*

Right *Study this diagram. It may help you to do convincing drawings of boats.*

Not this way This way

Not this way This way

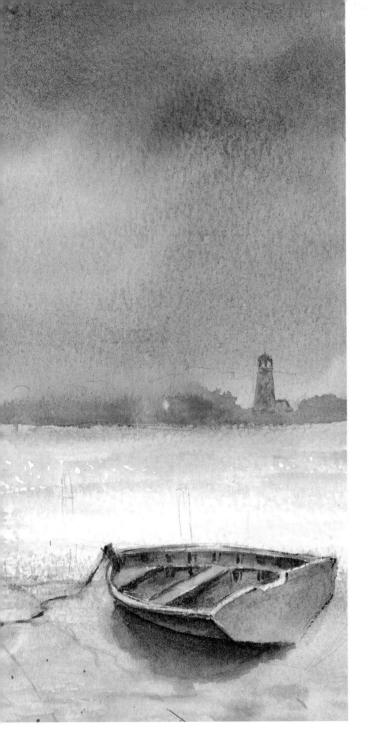

Hue

Hue is the name of the colour, such as yellow or orange. Hue is what most people are referring to when they describe an object's colour, for example a green car or a red apple.

Chroma

Chroma describes the brightness or intensity of a colour. Paint has the most intense colour when it comes directly from the tube, before you add water or mix it with other colours. Thinning the paint with water reduces both the value of a colour and also its brilliance.

Another way to reduce the intensity of a colour is by adding black. I prefer to reduce brilliance by adding the complementary colour.

Right *When a traffic light turns to red, we are seeing red in an intensity (chroma) that is greater than that of the other two colours.*

Creative Watercolour

Watercolour has a life of its own. It runs, it explodes and it has a wonderful translucency that is unique and atmospheric. In the next four exercises we'll play with these features.

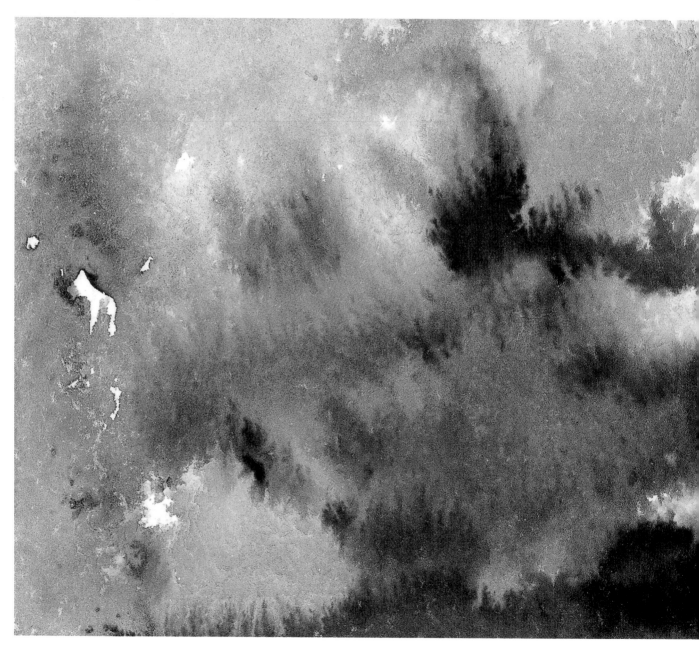

Monochromatic Painting

In this example, you'll be seeing how watercolour paint reacts with water. To keep things simple, use only one colour, Payne's grey. (A painting done in only one colour is called a monochromatic painting.)

1. Draw a rectangle that is the same size as my example and put masking tape all around it. Be sure to press the tape down firmly so that no water can get under it and spoil your painting.
2. With your No. 8 round brush, wet the inside of the rectangle with clean water.
3. Pick up a small amount of Payne's grey with your brush. Gently touch the colour into the wet rectangle and watch it explode and spread. This is the magic and excitement of watercolour.
4. In the mixing area of your palette, place some Payne's grey. Dip your brush into the clean water and mix it with the grey. Place some of this colour in the rectangle.
5. Now experiment. Try putting a very light colour in the rectangle, then a very dark colour. Try painting thin lines and thick blobs. Sometimes push hard on the paper with your brush, and at other times just barely touch the paper. Watch what happens as you experiment. Remember, you can't do anything wrong here. You are just learning how the paint reacts to water and pressure and whatever else you can think of. Keep going until you are happy with the results.

Don't try to make your painting look like my example. My example is only here to give you ideas on what to try. I do recommend that you have light, medium and dark values in your final painting, however, which will make it much more interesting.

Congratulations, you have painted your first abstraction!

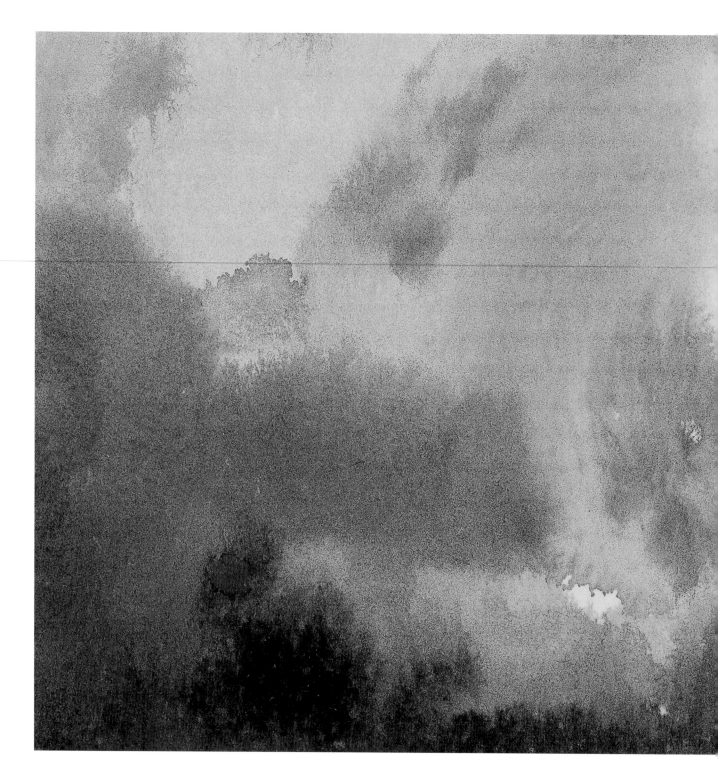

Analogous Colours

This painting is like the previous one except that you will be using analogous colours. These are colours that are next to each other on the colour wheel. We will use yellow, orange, red and black.

Yes, I use black even though there are many instructors who say you never should. (I believe there should be no 'nevers' in art – it destroys creativity.) I find black useful for dulling colours, darkening colours and producing interesting greys. It also introduces depth.

1. Draw a rectangle that is the same size as the example and put masking tape all around it. Be sure to press the tape down firmly so that no water can get under it and spoil your painting.

2. With your No. 8 round brush, wet the inside of the rectangle with clean water.

3. If you want an area to be yellow, paint it now. This is because every other colour is stronger than yellow. If you paint yellow on top of another colour, it will blend with that colour, and will no longer look yellow. You may also want to paint your oranges now for the same reason.

4. Experiment like you did in the last exercise. Mix colours together on your palette before putting them on the paper. Try mixing colours on the paper. Take your time, there is no reason to hurry.

Try to like what happens. Let some colours run freely into others. Take your time and watch the miracle take place. You can keep adding more pigment, but not more water. If more water is added to an area that has already started to dry, there will be a water spot (also called a back-run or a cauliflower), which can be a disaster in your painting. However, some artists deliberately use water spots in their works of art, so you might like to make one to study its effect.

Complementary Colours

This painting is like the last two except that you will be using complementary colours, which lie opposite each other on the colour wheel: red and green, blue and orange, or yellow and violet.

Left *Red and green* do *complement each other!*

1. Draw a rectangle and put masking tape all around it. Be sure to press the tape down firmly so that no water can get under it and spoil your painting.
2. With your No. 8 round brush, wet the inside of the rectangle with clean water.
3. Experiment, just like you did in the last two exercises. In my example, I started with the lightest colour, orange, and then slowly went darker with blue, then brown. Feel free to try your own ideas. Don't forget to experiment with the brush. Don't be afraid to press down hard on the brush and twirl it around or scrub the paper with it. It won't hurt the brush, and it could give you some interesting marks and textures.

Triadic Colours

Triadic colour schemes are made with three colours that form a triangle on the colour wheel. In my example, I used yellow, red and blue. Another example of triadic colours is green, orange and violet.

1. Draw a rectangle and put masking tape all around it. Be sure to press the tape down firmly so that no water can get under it and spoil your painting.
2. With your No. 8 round brush, wet the inside of the rectangle with clean water.
3. Experiment, just as you did in the previous three paintings. In my example, above, I again began with the less dominant colours then gradually went darker, so

I started with yellow, then added blue, then red. If you'd like greater depth of value, black can be added.

Congratulations, you have just produced your first masterpieces!

Making Watercolour Behave

You can control watercolour, but you need to
know how! Let me show you some of the most
useful ways to paint with watercolour. These are
painting flat, even washes, graded washes that
gradually change tone and variegated washes
that employ more than one colour.

Flat, Even Washes

Flat, even washes are an important concept.
Many times you'll want to paint a sky using this
technique. If a painting has a lot of activity on
the ground, you usually won't want the sky to be
too important. Besides skies, you could use this
technique on buildings, people, man-made
objects and many other things.

There are several ways to paint a flat, even
wash. I'll show you how to paint one directly
and one indirectly. The final result should look
the same.

Direct Method

1. Draw a rectangle, about 8 × 13 cm (3 × 5in).
2. Gently mix the colour you want to use on your palette. Try to mix enough paint so that you won't run out. In this exercise, I used ultramarine blue.
3. Tilt your paper up to an angle of about 20° so that gravity will help the wash move down the rectangle.
4. Load your No. 8 brush with the colour you mixed.
5. At the top of the rectangle, paint a horizontal line in a single stroke. (Do not press hard with the brush.) In a few seconds, a bead of colour will form at the bottom of your horizontal line.
6. Reload your brush with the same blue mixture. Paint another horizontal line, slightly overlapping the bottom of the previous brushstroke. A bead of colour will form at the bottom of your new stroke. Repeat this step until your rectangle is completely filled.
7. At the bottom edge, there will be a bead of colour. You'll need to remove it. To do this, squeeze your brush to rid it of some excess water, then move the brush over the bead. The brush will absorb the water.

If you see streaks, don't worry. It will take a few tries before you master this technique. Some things that could cause streaks are pressing too hard with the brush or getting too much water in the brush.

You could also get hard lines if one stroke starts to dry before the next stroke is made. This is why mixing enough paint before you begin is so important. If you need to stop and mix another batch of paint, the colour you placed on the paper will begin to dry. When you start painting again, you will see a hard line where the old and new paint meet.

Indirect Method

1. Draw a rectangle, about 8 × 13 cm (3 × 5in).
2. Gently mix the colour you want to use on your palette. Try to mix enough paint so that you won't run out.
3. Wet the inside of the rectangle carefully with clean water.
4. Using your No. 8 brush, pick up some of the colour you mixed. Touch it into the wet paper. You'll see the colour flow into all areas of the rectangle. Keep adding colour and moving it around the paper until you have a flat, even wash.

As watercolour dries, it becomes lighter. It can dry up to 50 per cent lighter.

Graded Wash

A wash that changes from light to dark or from dark to light is called a graded, or graduated, wash. It usually looks more interesting than a standard flat, even wash.

1. Draw a rectangle, about 8 × 13 cm (3 × 5in).
2. Tilt your paper up to an angle of about 20° so that gravity will help the wash move down the rectangle.
3. Mix a fairly strong colour on your palette. In my example I used ultramarine blue.
4. At the top of the rectangle, paint a horizontal line with your No. 8 brush. A bead of colour should form at the bottom of your horizontal line, just like it did for the directly painted, flat, even wash.

5. Dip your brush into the water container and then paint another horizontal line, slightly overlapping the bottom of the previous brush stroke. Repeat this step until your rectangle is filled.
6. At the bottom edge, there will be a bead of colour. Squeeze your brush to remove some water from it, then move the brush over the bead. The brush will absorb the bead.

Each time the brush is dipped into water, the paint in the brush becomes more diluted with water and each brushstroke becomes slightly lighter. This is very much the same idea that we used in doing the value scale. With practice you should be able to make a smooth transition from dark to light. Then try the opposite – start at the top with a very light value and slowly add more paint with each step toward the bottom.

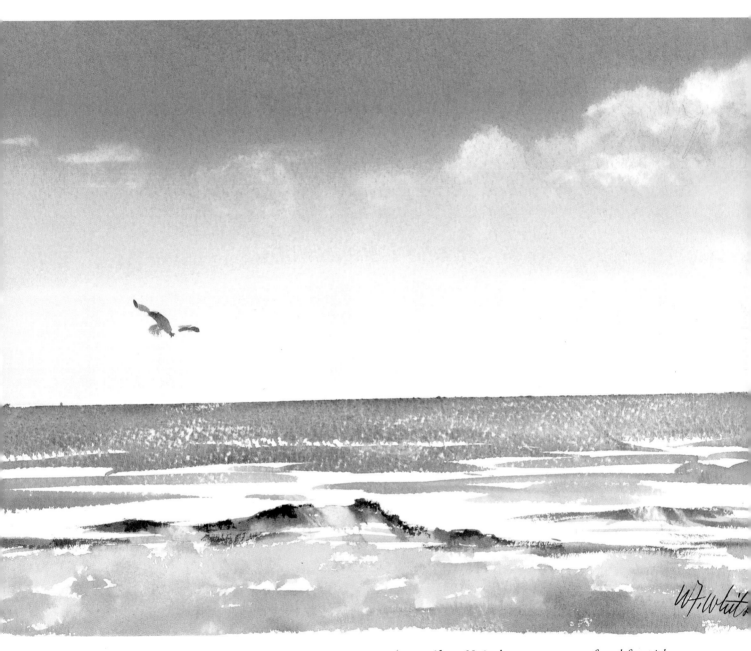

Above Notice how your eye moves from left to right by following the flight of the bird, the movement of the wave and the flow of the pattern of white. A feeling of space can be achieved by using graded washes in the sky, water and land.

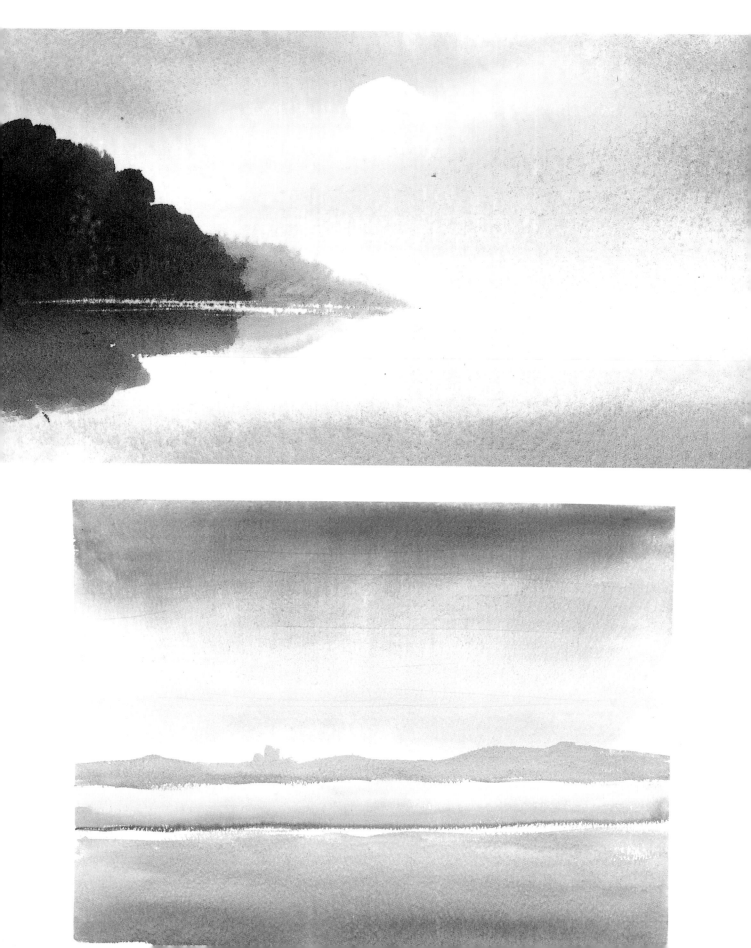

Above To accomplish the misty, Eastern mood in
this painting, I used variegated washes (see page 36
for details). I dampened the entire page and
gradually introduced more colour and detail as the
painting dried.

Opposite page This is an example of a painting
done with graded washes – dark to light in the sky
and light to dark in the water.

Variegated Wash

Any area of your painting will usually be more interesting if you use more than one colour. This is called using variegated colour. This technique is similar to painting a flat, even wash indirectly.

1. Draw a rectangle, about 8 × 13 cm (3 × 5in).
2. Wet the inside of the rectangle carefully with clean water.
3. Place several different colours into the rectangle while it is wet and gently sweep the colours together.

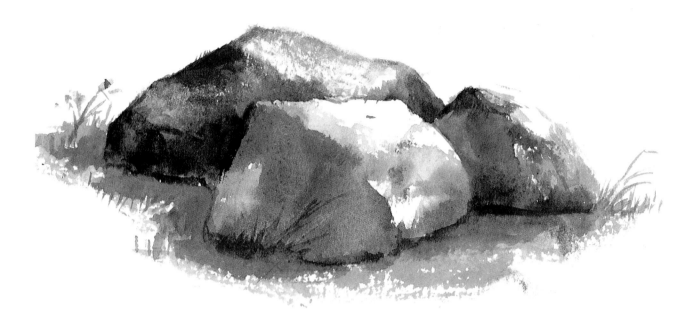

Above These rocks were painted using the variegated wash technique. The colours of the rocks vary from dark to light and from warm to cool to make them more interesting.

Below The use of soft, variegated washes helps to convey a feeling of life and movement in these crashing waves.

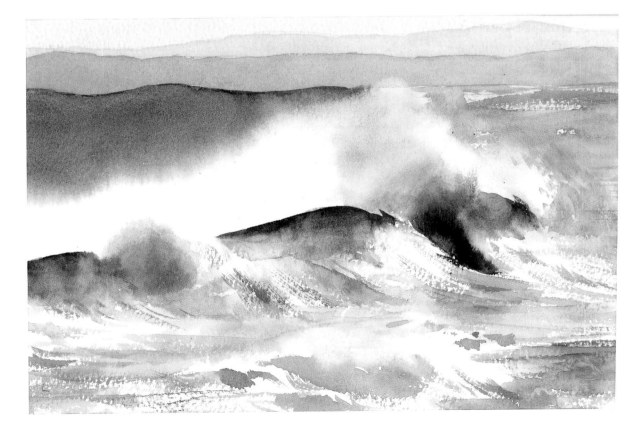

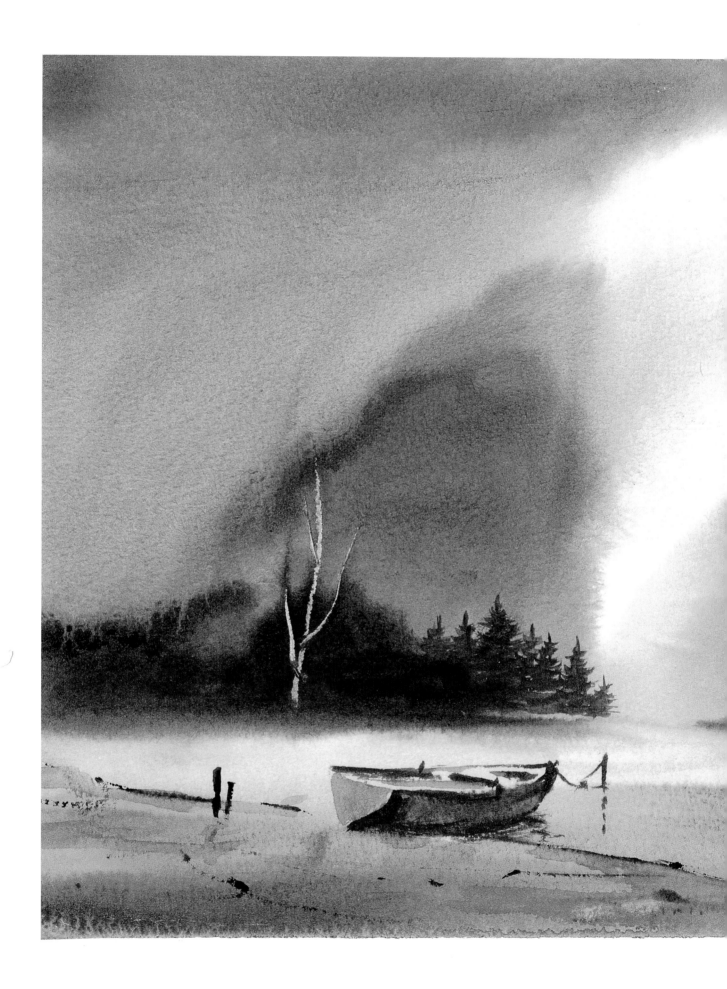

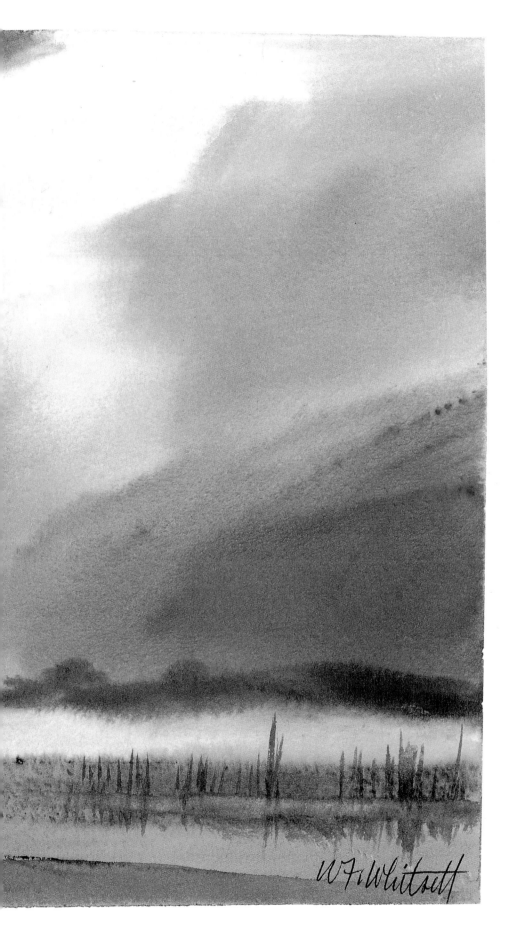

Left *To emphasize the centre of interest in this painting, I used contrasting dark and light patterns. Notice how the boat, the line of trees and the foothills all point to the spot of greatest contrast.*

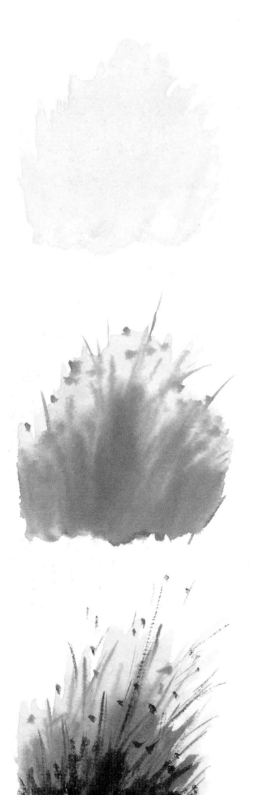

Dryer-Into-Wet Technique

This technique (also known as Wet-Into-Wet) is, in my opinion, one of the best ways to produce soft, rich, velvety qualities. The secret of this technique is very simple – you can add more pigment to a damp area, but you must not add more water. If you add more water to an area that has started to dry, you will develop a water spot. This is why I prefer to call this method dryer-into-wet instead of wet-into-wet. Dryer-into-wet describes the technique better and also helps beginners avoid the mistake of adding more water instead of only adding more pigment.

1. Lightly draw a patch of weed on your watercolour paper.
2. Create a mixture of yellow ochre on your palette.
3. Apply the yellow ochre mixture to your drawing.
4. Add Prussian blue and yellow ochre to your brush. Do not add water to your brush or rinse the brush before doing this. This is the dryer-into-wet technique, so you are adding more pigment to your brush, but not more water.
5. Apply this new paint to the moist wash you painted in Step 3. Watch how the new paint spreads into the moist wash and increases the value contrast and textural excitement.
6. Create a mixture of burnt sienna and Prussian blue that is less moist than the mixture you created in Step 4.
7. Apply this new mixture into the still-damp green of Step 5.

Above Without strongly contrasting darks and lights, the petals would seem flat instead of wavy and curvy. The dryer-into-wet technique is ideal for depicting the soft quality of iris petals.

W.Whitsett

Dry-Brush Technique

Dry brush is a technique used to create a variety of textures. With this technique you are gently laying colour on the bumps of the paper. This allows the white of the paper to push through.

The term dry brush is not accurate, but it is a convenient name. If the brush were completely dry, you would not be able to place any paint on the paper. When you use this technique, the brush is moist and a minimum of water is used with the pigment.

1. Moisten your No. 8 brush.
2. Squeeze the brush at the ferrule (the metal part) to fan out the bristles. See illustration below.
3. Gently pick up some pigment with the fanned-out brush.
4. Hold the handle of the brush so it is almost touching your paper. Now, very gently, without putting any pressure on the brush, move it across the paper.

When you are comfortable with the dry-brush technique, try using it to paint grass, bricks and old wooden boards.

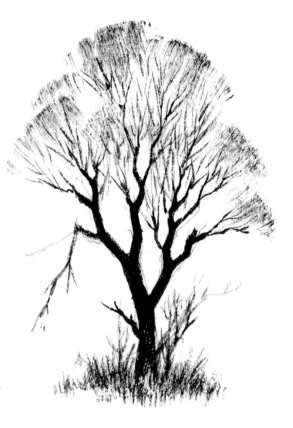

Above *This simple tree was painted using the dry-brush technique described on this page.*

Opposite page *Painting of gatepost at Flatford. I built up the texture of old wood by using the dry-brush technique. This composition is based on a repetition of diagonals.*

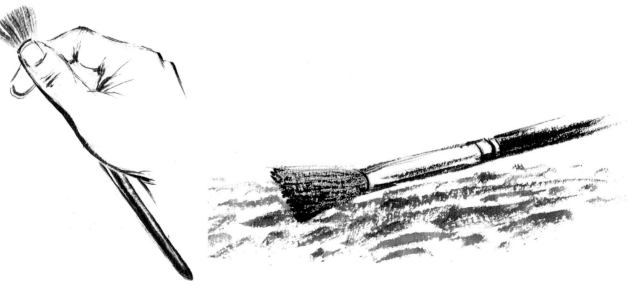

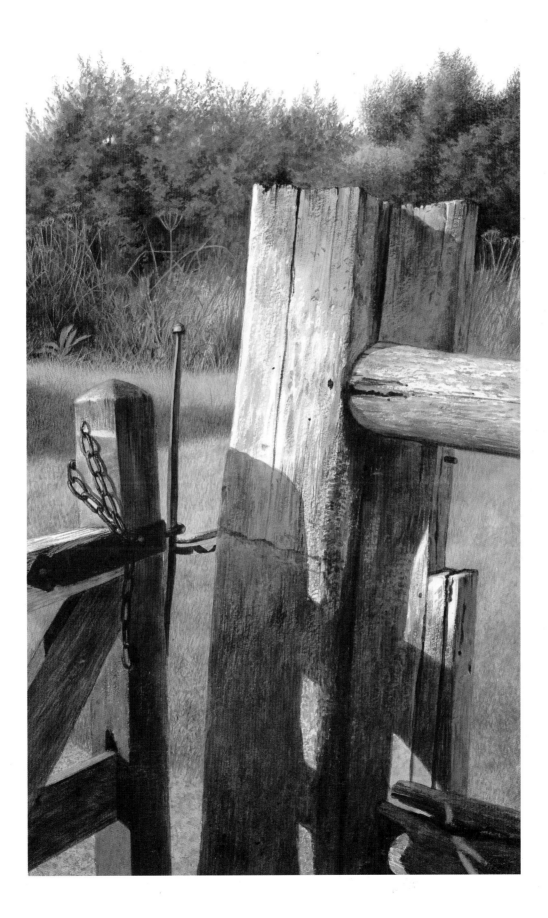

Chapter 2
Landscape Elements

Now that you have learnt the basic techniques, it's time to put them together. An excellent place to start is the beautiful and varied landscape that surrounds us and provides a wealth of inspiration.

***Below** The feeling of space in this scene has been emphasized by the transition in scale from the boats in the foreground and the man and dog in the distance.*

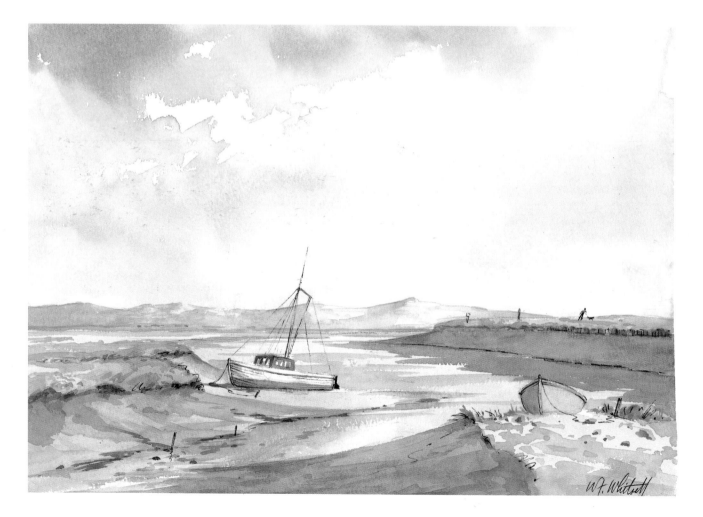

Into the Blue

Skies are important. The sky affects every colour of every element in a landscape and helps to create the mood of the painting. If a sky is not done well, the whole painting may suffer.

Summer Sky

In this example, I used a wash technique to paint the colours I usually see in a summer sky. Near the ground it is yellowish, and as you slowly look up, there is light blue that gradually moves into a deeper blue.

1. Draw a rectangle the same size as the example given above.
2. Turn your paper upside down – it is easier if you paint the lightest colours first.
3. Tilt your paper up to an angle of about 20° so that gravity will help the wash move down the rectangle.
4. Make a pale yellow ochre mixture and load your No. 8 brush with it. Start at the very

top with horizontal brush strokes of the pale yellow ochre. Continue this colour down about halfway, using a series of overlapping strokes of burnt sienna.

5. Clean the brush and remove the excess water from it with a tissue before mixing the next colour.

6. Load your brush with a mixture of yellow ochre and Prussian blue (in the right proportions to produce a light blue, not a green).

7. Paint another horizontal line, slightly overlapping the bottom of the previous brush stroke.

8. Clean the brush and remove the excess water from it with a tissue before using the next colour.

9. Repeat Steps 7 and 8 with ultramarine, then again with a mixture of ultramarine and Prussian blue.

10. At the bottom edge, there will be a bead of colour. Squeeze your brush to remove some water from it, then move the brush over the bead. The brush will absorb the bead.

11. When the sky is dry, make a mixture of alizarin crimson, burnt sienna and Prussian blue and, with your large, flat brush, paint the bottom dark shape, which identifies the trees.

12. When the wash has dried, turn the paper upright. You have painted a summer sky!

Below *Notice how the small figures of the man and dog become the centre of interest in this painting.*

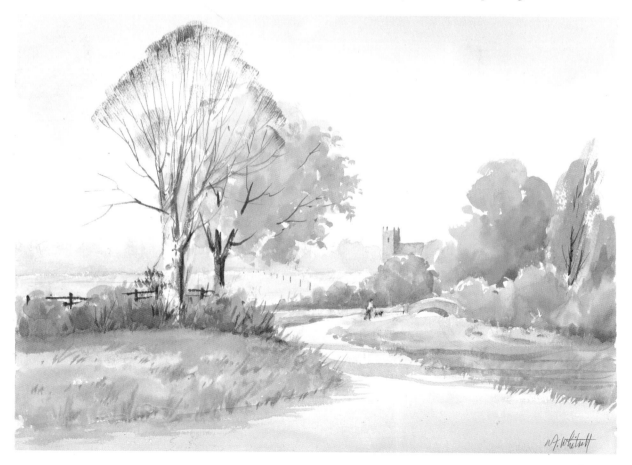

Sky with Clouds

In this exercise, you'll be trying to get a feeling of space using soft-edged cumulus clouds. Each cloud should have a different size and shape. To keep things simple, one cloud should be large, the second medium and the third small, etc. In my example, the smaller the cloud, the further away it seems.

1. On your palette, mix a colour that is mostly Prussian blue with a little burnt sienna. The brown will reduce the blue's intensity.

2. Before you begin painting, stop and think about what you want to do. This exercise is basically a design problem. You want to make interesting cloud shapes, but they don't have to be complicated to be good.

3. Paint a flat, even wash over the entire sky using your No. 8 brush.

4. While the wash is still wet, use a crumpled tissue to blot out the shapes of the clouds.

These steps describe a simpler sky than the one seen in the picture. Try it first before you go on to paint more ambitious skies.

Stratiform Sky

This sky is painted using the dryer-into-wet technique. Because of this, you will need to move rather quickly because the sky must be completely painted before any of the paint dries.

1. Make a light mixture and a darker mixture using Payne's grey.
2. Paint a flat, even wash over the entire sky area with the light grey mixture.

3. Before the sky area dries, apply the darker mixture of Payne's grey using horizontal brush strokes that begin at one end of your paper and end at the other.

Try to get a variety of brush strokes with the widest at the top and narrowest near the bottom. This should give an illusion of deep space.

Opposite page top Warm colours unify this painting and the quietude of sunset is expressed with the repetition of horizontals.

Opposite page bottom Cool colours were used to create this quiet morning mood. When your painting includes similar objects, like the boats, try to give each a distinctly different size and shape.

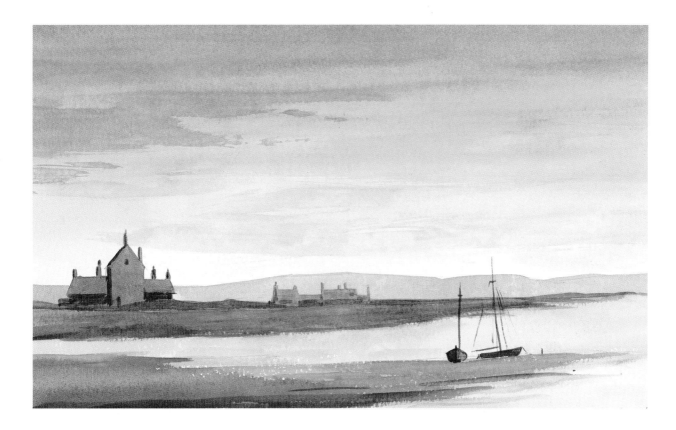

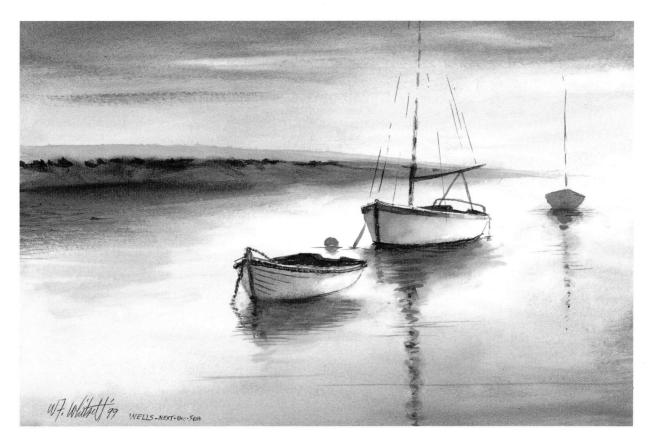

W.F. Whitott '99 WELLS-NEXT-the-SEA

Stormy Sky

This sky is also painted using the dryer-into-wet technique. When painting it, you will need to think like a designer. Try to create movement with your darks and strive for an exciting yet pleasing abstract pattern.

1. Tip your board to 75 degrees.
2. Using your large brush, wet the area from the top and immediately, using your No. 8 brush, drop in a strong mixture of ultramarine.
3. Let the paint run down for a streaky effect.
4. To control the running paint, lower the angle of the board and, with your clean large brush, move horizontally across the paper to absorb the excess paint. This will require practice!

Opposite page top *To heighten the drama of this snow scene, I forced darks against lights and painted a single area a brilliant yellow as a centre of interest.*

Opposite page bottom *Watercolour is an ideal medium for expressing storms. The variegated colours run together, giving the painting a life of its own.*

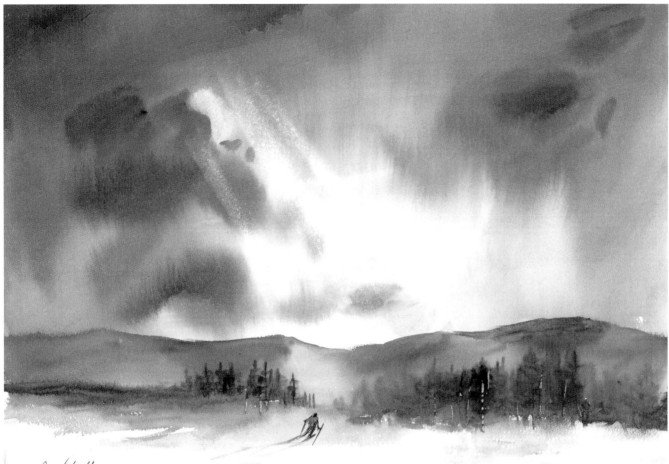

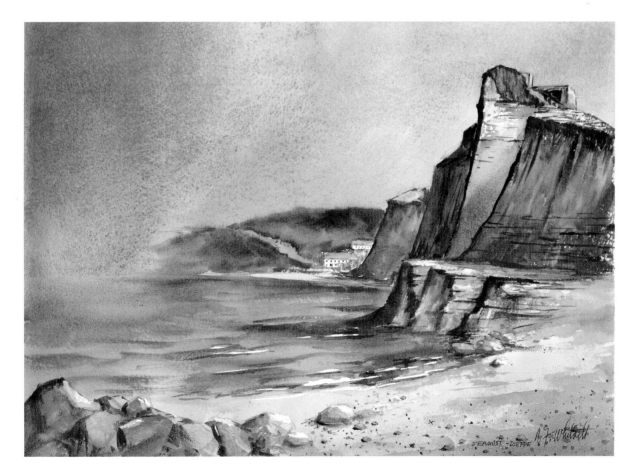

SEAMIST - DIEPPE

Green is Beautiful

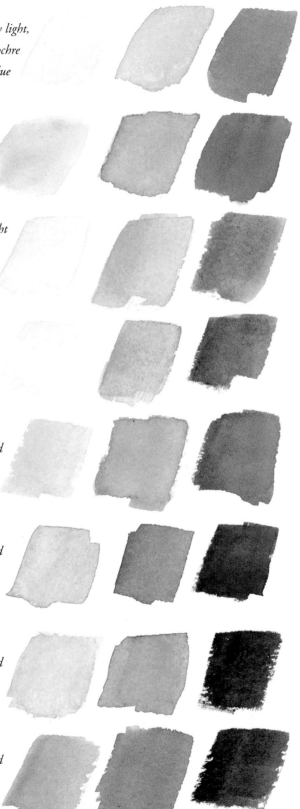

Cadmium yellow light,
yellow ochre
and Prussian blue

Yellow ochre and
viridian

Cadmium yellow light
and ivory black

Cadmium yellow light
and Payne's Grey

Burnt sienna and
viridian

Prussian blue and
burnt sienna

Viridian and
alizarin crimson

Viridian and
ivory black

You can buy many shades of green at the store, but you can create all of them and more by mixing two or three other colours together. In this exercise, you'll be mixing some of your own greens. If one of the colours you will be using is yellow, I recommend that you start with the yellow, then slowly add the next colour. This is because yellow is a weak colour, so unless you are careful other colours could overpower it.

1. Mix cadmium yellow light and Prussian blue together to make green. Add a bit more yellow, and you'll get another shade of green. Add more blue, and you'll get yet another shade of green. This is part of the excitement of colour, and one of the challenges.

2. Try mixing some other colour combinations. In my example, left, I created shades of green with each colour combination I've listed. See if you can match them.

There are many ways to mix greens. These are just a few of the many combinations you could use.

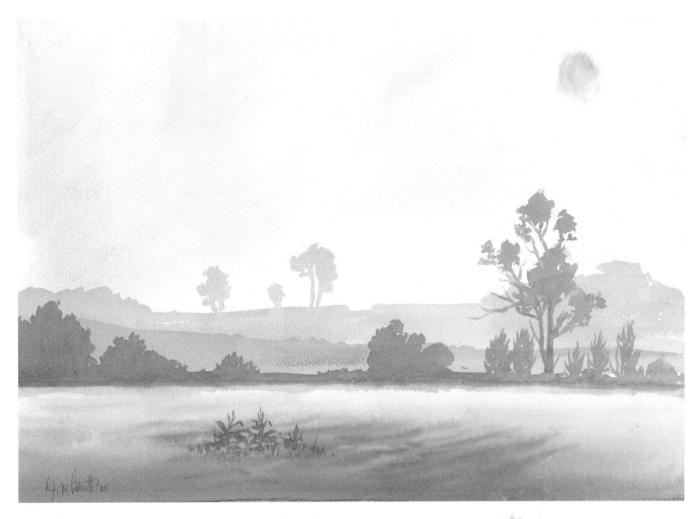

When students paint grass and trees, they often make them too bright. Take a close look at the greens around you in nature. The greens may look greyed by atmosphere, humidity and variations in sunlight. When translated into paint, this results in greens that tend to be softer and bluer.

Above *I was up at 6 am to catch this sunrise at Flatford Mill. The painting is unified with cool greens.*

Right *The leaves on the sunflowers in this painting are made up of many different greens.*

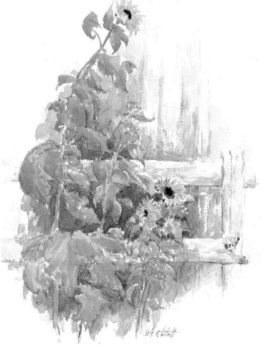

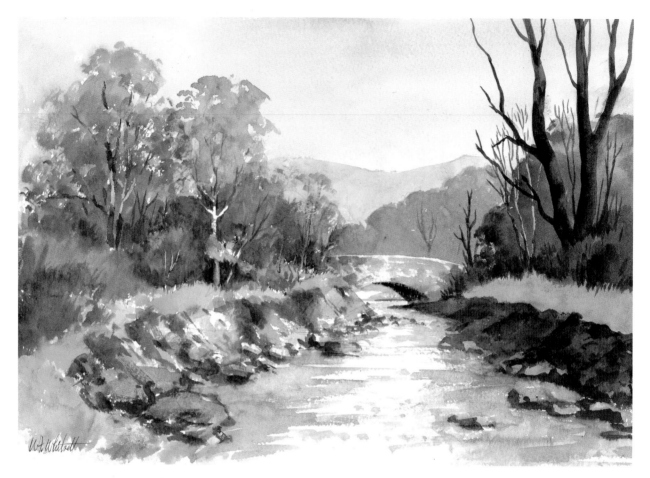

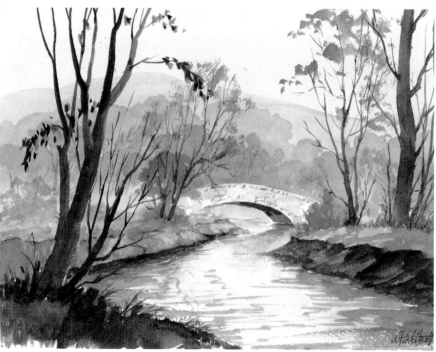

Above *We are all equipped with eyes that have a 'zoom' lens, which can often dramatize a subject and help us find interesting shapes.*

Left *In this painting, the river banks were used as compositional 'lead-ins' to the bridge, the centre of interest. Atmospheric perspective has been used here to create the illusion of distance.*

Trees for All Seasons

Each type of tree is very distinctive, but the basic technique I use to paint them is almost the same. It is the shape of the tree that tells us what type it is. Because of this, it is important to have a sense of the structure of the tree in mind before you start.

Maple Tree

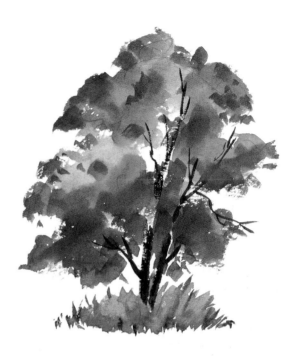

The basic shape of a maple tree is like a hand, and its branches grow at an angle of about 30°.

1. It's a good idea to lightly draw the tree you are going to paint. I first draw the outline of the foliage. Make the shape of the tree interesting – try to avoid making it a circle or a totally triangular shape, and avoid making it perfectly balanced.
2. The autumnal colours can be painted by using yellow ochre, Winsor red, burnt sienna and burnt umber.
3. Use your No. 8 brush to paint the foliage. In some places, try pressing down harder on the brush and in others use only the tip of the brush. This will give irregularities that suggest the foliage. Also leave some bird holes (places with no paint). They add interest.
4. Mix the colour for the trunk of the tree. I used viridian and burnt umber.
5. Paint the trunk and branches with your No. 8 brush. Make the trunk lighter in

a few places, where the light hits it. When you put the branches in, make sure the spaces between them are not all the same. Maybe add a broken branch. Don't forget that the diameter of a branch gets smaller the further away it is from the trunk.

When I need a fine point on a brush, I load it with the colour I want, then gently twirl it on the palette.

Oak Tree

The basic structure of an oak tree is very different from that of a maple. The branches of a maple all seem to grow at the same angle, but the branches of an oak grow in many directions. This autumn tree is painted using the dryer-into-wet technique.

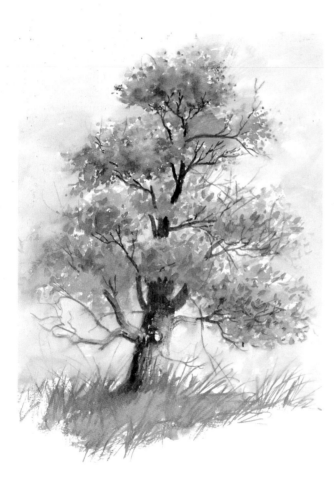

1. Lightly draw a tree with foliage areas. Each area should have a different size and shape, as in my example.

2. With your No. 8 brush, use yellow ochre to paint one of the foliage areas. Oak leaves are sharp, so you might like to suggest that sharpness in some places on the edges of the foliage areas. Before painting, think carefully about what you want to do. Watercolour likes to be used very simply and directly. It doesn't react well when you go back in and play with it as it is drying.

3. If the yellow ochre area is very wet, let it dry a little before continuing. Do not let it dry completely.

4. Notice that you can clearly see where the light and shadow areas are.

5. With your No. 8 brush, pick up some burnt sienna but do not pick up any more water. Place this colour in the shadow areas of the tree. Notice how the paint spreads into the yellow ochre.

6. Let the burnt sienna area dry a bit before continuing, but not completely.

7. With your No. 8 round brush pick up more burnt sienna but no water. You may want to remove some water from your brush with a tissue. Place the burnt sienna in the darkest shadows.

8. Repeat Steps 2 to 7 to paint the second foliage area and then the third, etc.

9. Mix ultramarine and burnt umber for the trunk and branches.

10. Before you begin painting the trunk and branches, notice how the branches hold the leaves. Also remember where the light source is. This will tell you which areas should be painted lighter or darker.

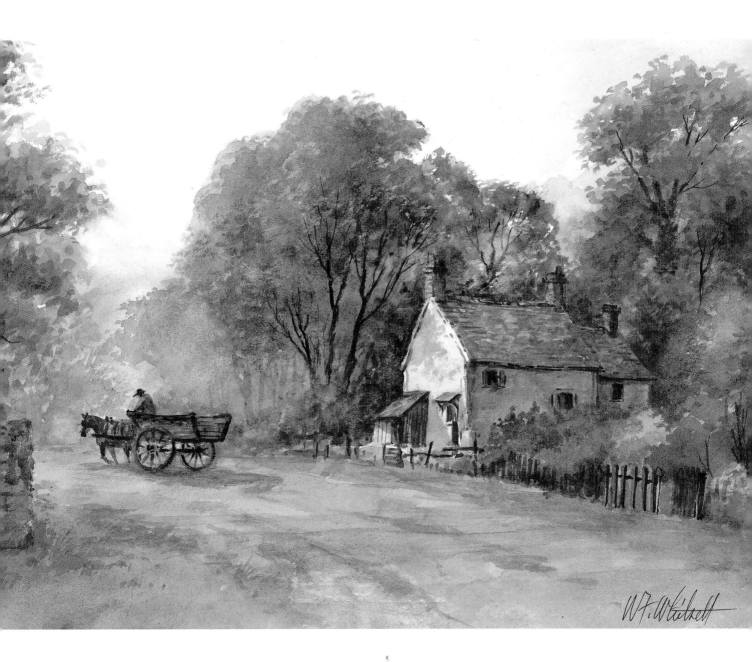

When drawing on watercolour paper, don't press hard or you might engrave the line into the paper. When you paint over the engraved line, pigment will accumulate there and when it dries, you will get a dark line.

Above *Sometimes I paint on location and other times I paint using photographs, but this landscape was painted from my imagination.*

Above Sometimes I select unusual views of my subject to achieve more dramatic compositions. Look at your subject from various angles to find the best view.

Right A sense of scale was achieved by contrasting the small yellow flower against the large oak tree.

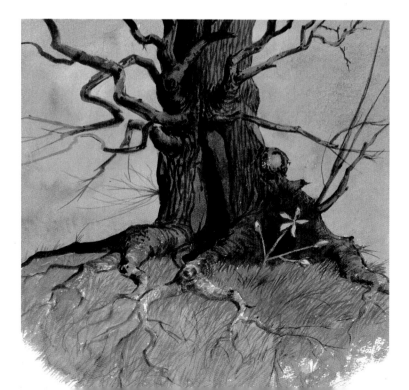

Conifers

Pine trees are great fun to paint. After you master this technique, you'll be able to paint your own Christmas cards.

1. Mix a green using burnt sienna and some Prussian blue.
2. Use your No. 3 brush to paint a vertical line for the trunk.
3. Paint curving 'X's through the vertical line. Each 'X' should be smaller than the one below it.
4. With a drier brush and a lighter colour, repeat the 'X' pattern using a thicker stroke. Repeat this rhythmic stroke until you get a complete tree.

To make your pine trees more interesting, you may want to make one with blues in it, one with yellows in it and one with reds in it. You can either mix the colour in your green or dry brush it on later. Variegated areas (areas with more than one colour) usually entertain the eye of the viewer more than an area with only one colour.

Below *Landscape with pine trees and stormy sky. The drama can be heightened with a contrasting range of colours from white to black.*

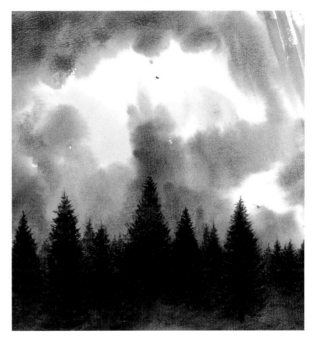

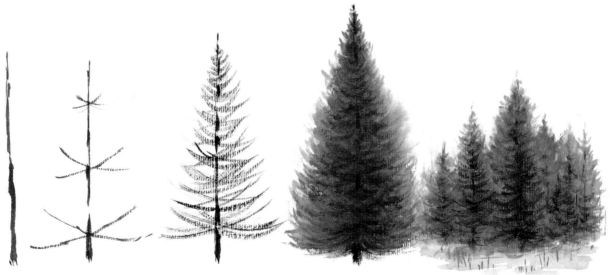

Winter Trees

The example shown below is of a maple tree. Notice the 30° angle of the branches. At the tips of the branches you'll see where last year's growth occurred. However, these steps describe the tree pictured on page 42, which is simpler for the beginner. The main technique you'll be using is the dry-brush technique.

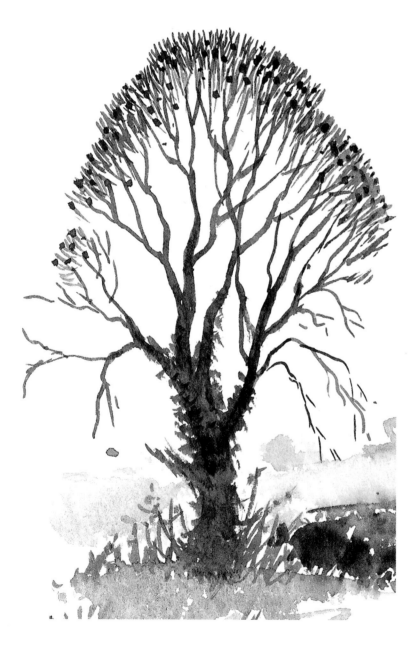

1. Lightly draw the general shape of the tree and also draw in the trunk and main branches.

2. Mix ultramarine and burnt umber to create the colour for the terminal endings of the branches (where next year's leaves will grow). Mix a darker colour of this mixture for the trunk.

3. Paint the terminal endings first. Using your No. 8 brush, pick up some of the terminal ending colour. Fan out the brush by pinching the hairs near the ferrule (the metal part of the brush). There should be spaces between some of the bristles of the brush. You may need to remove excess water with a tissue. Paint in the endings with long gentle strokes that barely touch the paper. You only want to put paint on the top of the bumps on the paper.

4. Paint in the trunk and branches. Notice the 'Y' shapes they make throughout the tree. As you go down a branch, press down harder on the brush so your stroke will get fatter. For the very fine lines at the ends of the branches, try holding your brush at a 90° angle from the paper.

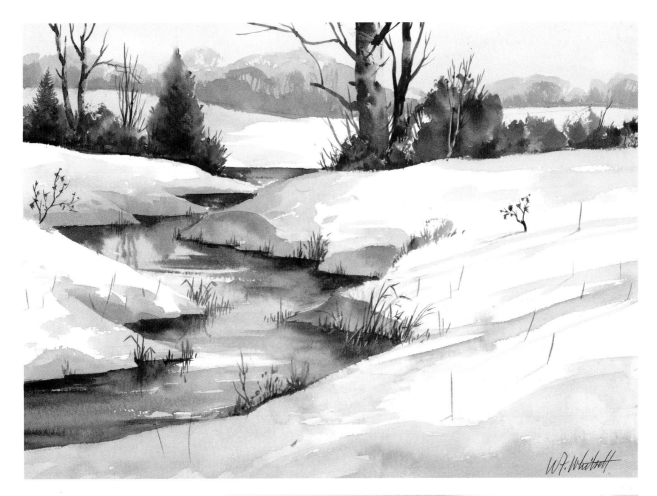

Above *Observe how the darks are connected into a pattern that unifies the composition.*

Right *You don't need to use a lot of colour to make an effective painting. This snow scene was done with Payne's grey only.*

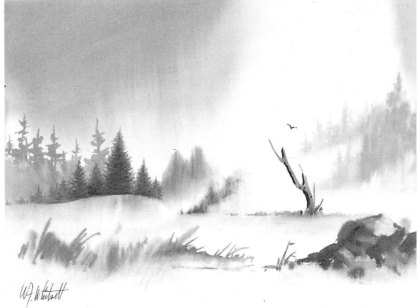

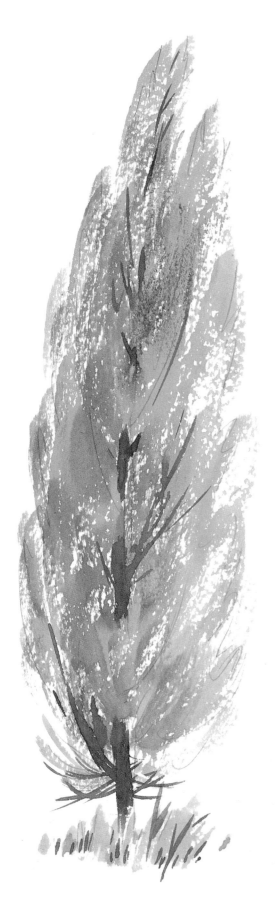

Lombardy Poplars

This is a majestic tree that gently sways with the slightest breeze. It will be painted using the dry-brush technique.

1. Lightly draw the outline of the foliage:
2. Mix a yellow-green using cadmium yellow light, yellow ochre and Prussian blue.
3. Load your No. 8 brush with the yellow-green you just mixed.
4. Spread the hairs of the brush into a fan shape by squeezing them near the ferrule with your thumb and forefinger.
5. Using a gentle downstroke that barely touches the paper, suggest the foliage.
6. Mix the colour of the trunk with burnt sienna and Prussian blue.
7. Paint the trunk and the branches.

Opposite page top *A variety of simplified trees. Perhaps these idiomatic trees will help you get started with the concept of simplification.*

Opposite page bottom *Usually trees are decorative or background elements in a composition rather than portraits and look better when painted very simply.*

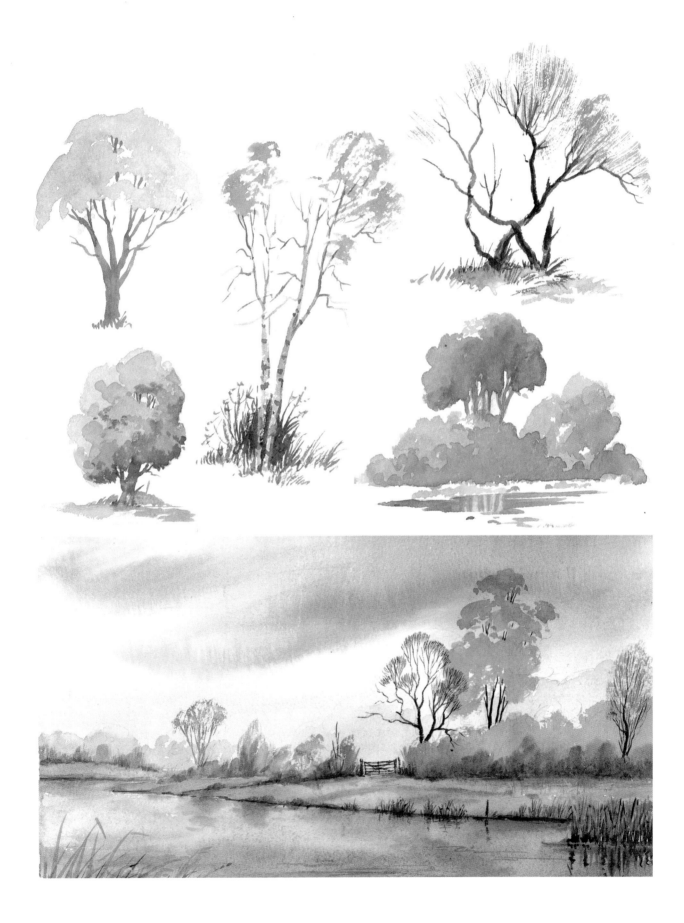

The Illusion of Space

This exercise uses only one colour – Payne's grey. We will vary the values of this colour to create the illusion of space. Other terms for this are atmospheric perspective and aerial perspective. Flat, even washes will be used to paint the mountains, while a graduated wash will be used for the sea.

1. Sky

Preparing to Paint

Tape all four sides of the watercolour paper onto your drawing board. Firmly press the tape down all around. This should prevent the paper from buckling when it is wet. (If you are using a pad of prestretched paper, you don't need to do this.) Lightly draw the scene, referring to the finished painting on page 66.

2. Distant mountain

1. Sky

The sky will be your lightest value. Using the flat brush, paint the sky with a graded wash. Soften the bottom of the wash and let the painting dry before continuing. To soften an edge, rinse your brush, squeeze out most of the moisture, then quickly brush across the edge.

3. Intermediate mountains

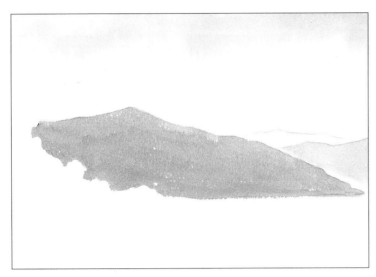

4. Foreground mountains

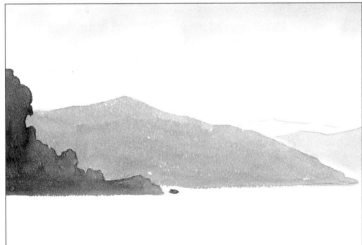

5. Rocky projection

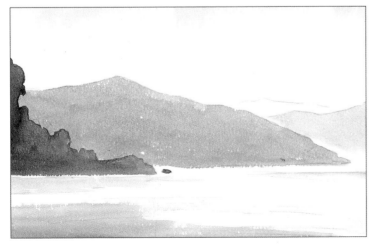

6. Sea

2. Distant Mountain

Using a value that is slightly darker than the sky, paint the distant mountain with a graded wash. Soften the bottom edge of the wash and let the painting dry.

3. Intermediate Mountains

Using a value slightly darker than that used for the distant mountain, paint the intermediate mountains. Soften the bottom of the wash to suggest haze and permit it to dry.

4. Foreground Mountains

Using a value slightly darker than that used for the intermediate mountains, paint the foreground mountains down to the sea. Leave to dry.

5. Rocky Projection

Paint the dark rocky projection in the foreground an even darker value than the foreground mountains.

6. Sea

Paint the sea with a graduated wash. Start at the top of the sea under the mountains by painting a triangle as shown. Strengthen (darken) the value (tone) of each abstract shape as you move towards the bottom, where the shape is the largest.

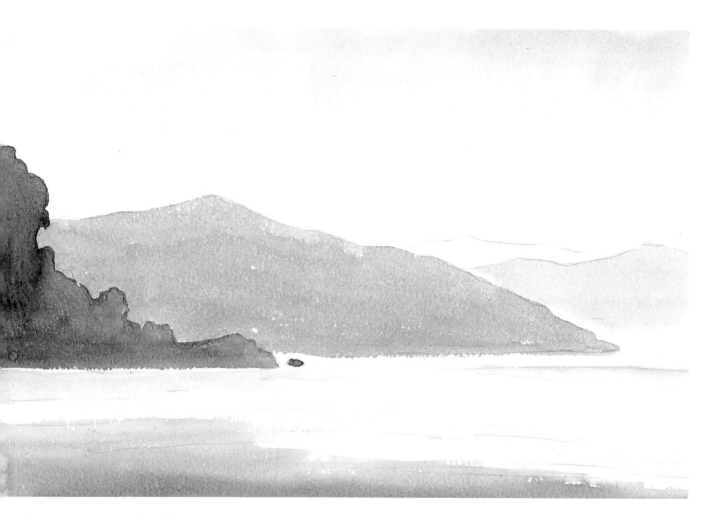

Above: *The finished painting.*

The concept of creating the illusion of space by using varying values is fundamental to most landscape painting. Usually, the further back an object is, the lighter and greyer it is. (To grey a colour, use its complementary colour.)

Paint Along with Bill

Before we start this painting, I want to emphasize that there are many ways to paint landscapes, and this is only one. I hope that as you become more confident you will experiment with many other techniques.

This painting will be done using the flat brush, the No. 8 brush and a limited number of colours: Prussian blue, alizarin crimson and yellow ochre. It is a good idea to test the colours you mix on a scrap of paper. Don't forget, watercolour dries much lighter than when first applied.

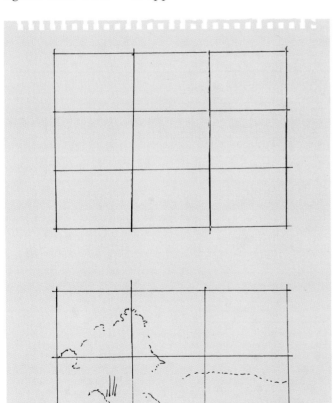

Drawing

Referring to the finished painting on page 72, draw the scene on your watercolour paper using a sharp HB pencil. One way to make an accurate copy is by using a grid, which you can do in the following way:

1. With your ruler, take the painting in this book and divide it up evenly as shown in the diagram (below left). If you draw the lines lightly, you can go back later and erase them.
2. Draw a similar grid on your watercolour paper.
3. Look at one square of the painting in the book and copy the contents of this square into the same area of the grid on your watercolour paper. Continue copying squares until you have completely copied the painting.
4. Erase the grid lines from your watercolour paper. If you feel that any lines in your drawing are too dark, lighten them.

Preparing to Paint

1. Tape all four sides of the watercolour paper onto your drawing board. Firmly press the tape down all around. This should prevent the paper from buckling when it is wet. (If you are using a pad of prestretched paper, you don't need to do this.)
2. Arrange your work area as shown in the illustration on page 15.
3. Remove all unnecessary items from your work area.

1. Sky

Tilt your paper up to an angle of about 20° so that gravity will help the wash move down the rectangle.

The sky will be painted with the flat brush using the graded-wash technique. Paint the sky using Prussian blue diluted with a generous amount of water. (Refer to the section on Graded Wash in chapter 1, page 32, to review how to do this.)

You could paint the sky across the entire page, starting from the top of the page down to the sea line, painting over the areas that will contain large trees and bushes as well as the distant hill and trees. This technique is not shown here.

Permit the sky to dry before laying your board flat.

1. Sky

2. Distant hill

2. Distant hill

Mix Prussian blue with a small amount of alizarin crimson and lay a flat, even wash that starts at the top of the far hill and goes down to the distant land area. Let the painting dry.

3. *Distant trees and shore*

Mix Prussian blue with yellow ochre and paint the distant line of trees (down to the beach area). Don't forget to test the colour before using it on your painting. Allow the painting to dry before continuing.

For the distant shoreline, lay a light wash of yellow-green on the beach behind the shore. This is a mixture of yellow ochre and Prussian blue. Allow the painting to dry before continuing.

Any time you feel that an area you painted could be too light, wait for it to dry (so you can judge its colour at its lightest), then paint the same colour mixture on top of the dry area. This will make the area darker.

3. Distant trees and shore

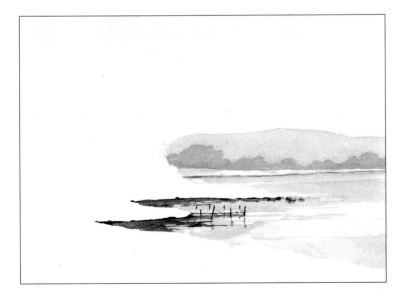

4. *Water*

Dampen the area of the water. Tilt your paper up to an angle of about 20°. Apply a graded wash of Prussian blue that is darker at the distant shore and lighter as you bring the wash forward to the near shore. Allow the painting to dry before continuing.

4. Water

5. Large land area

Lay a very light wash of warm colour over the area. This is a mixture of yellow ochre, Prussian blue and alizarin crimson, plus a generous amount of water to make the mixture very pale. Mix and test the colour on a scrap of paper before using it on your painting. Allow the painting to dry.

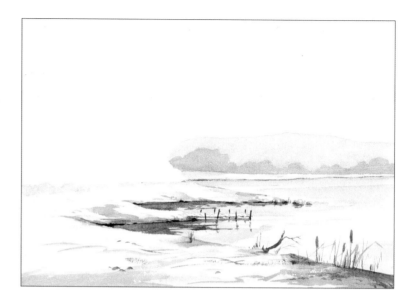

5. Large land area

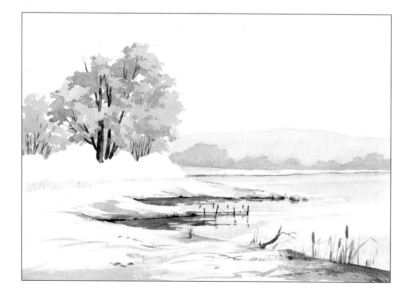

6. Large tree and brown trees

6. Large tree and brown trees

Mix yellow ochre and Prussian blue and test the colour. Make sure it is the colour you want by allowing it to dry. Apply the colour to the foliage, then let it dry again. The shadows will be applied later using a layering technique.

For the brown trees, mix and apply a very light value of alizarin crimson, yellow ochre and a small amount of Prussian blue. Test the mixture on a scrap of paper before using it on your painting. Let it dry.

7. Green bushes and yellow-orange bushes

Mix yellow ochre with Prussian blue and apply to the green bush area. Cover both bushes completely, including the shadow areas. Permit drying.

For the yellow-orange bushes, mix and apply alizarin crimson with yellow ochre. Cover the areas completely, but test the colour before using it. Permit drying.

8. Shadows

Shadows are painted with greys. Refer to the Chapter 1 section, 'Colour is Exciting!' to review the concept of complementary colours.

1. Mix Prussian blue, alizarin crimson and yellow ochre to make a grey. Test the colour before using it. This should be a greenish grey. When you are satisfied that you have created the correct colour, apply it to the shadows in the foliage of the large tree.

2. Using the same mixture, apply it to the shadows of the green bushes.

3. Create a mixture of yellow ochre and Prussian blue and apply it to the shadows of the yellow-orange bushes. Test the colour before using it. Allow the painting to dry completely before continuing.

4. Using a very light value of yellow ochre, alizarin crimson and Prussian blue, paint the grey-violet shadows on the ground as indicated. Test carefully. Allow the painting to dry before continuing.

5. Using the same grey-violet colour mixed with less water, apply a dark mixture to the structure of the trees and to the dark shadows of the shoreline. Allow to dry.

6. With the same dark grey-violet colour, paint the uprights of the jetty (landing), the strange tree stump and the weeds. Use the No. 3 brush for this.

7. Using a variety of light greys, paint the textures on the land and the dark line of the distant shore.

8. You can indicate water by applying very light, horizontal shapes using Prussian blue with a touch of alizarin crimson.

9. Paint the bird with the No. 3 brush using a dark mixture of Prussian blue and alizarin crimson.

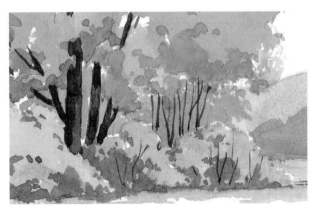

7. Green and yellow-orange bushes

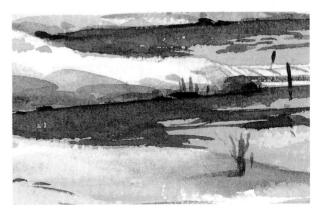

8. Shadows

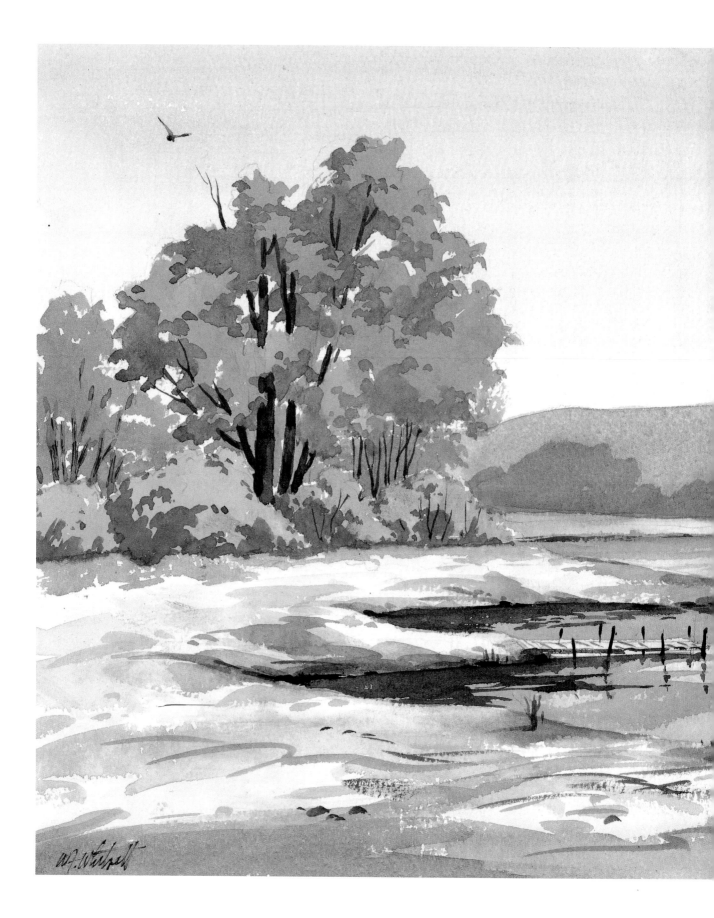

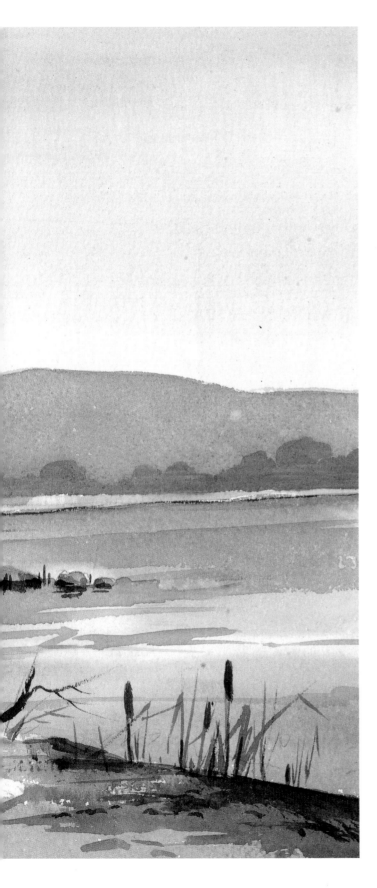

Congratulations!

You have painted your first complete landscape painting. Although it is a copy of my painting, I hope that this has been a worthwhile experience for you. I have attempted to show you in some detail exactly how I like to proceed with a landscape painting. Perhaps you now have a better understanding of how to mix colour as well as how to build colours with the layering technique. Keep painting – it's great fun. Don't be discouraged if you have encountered difficulty. Practise, practise, practise – I know you can do it!

A word of advice:

When you copy another person's original painting or photograph, it is illegal to sign your name to it or to sell it as your own original.

Notice that in this autumn landscape the closest elements are brighter and more detailed. The farther away an object is, the less detail it has and its colours are less bright.

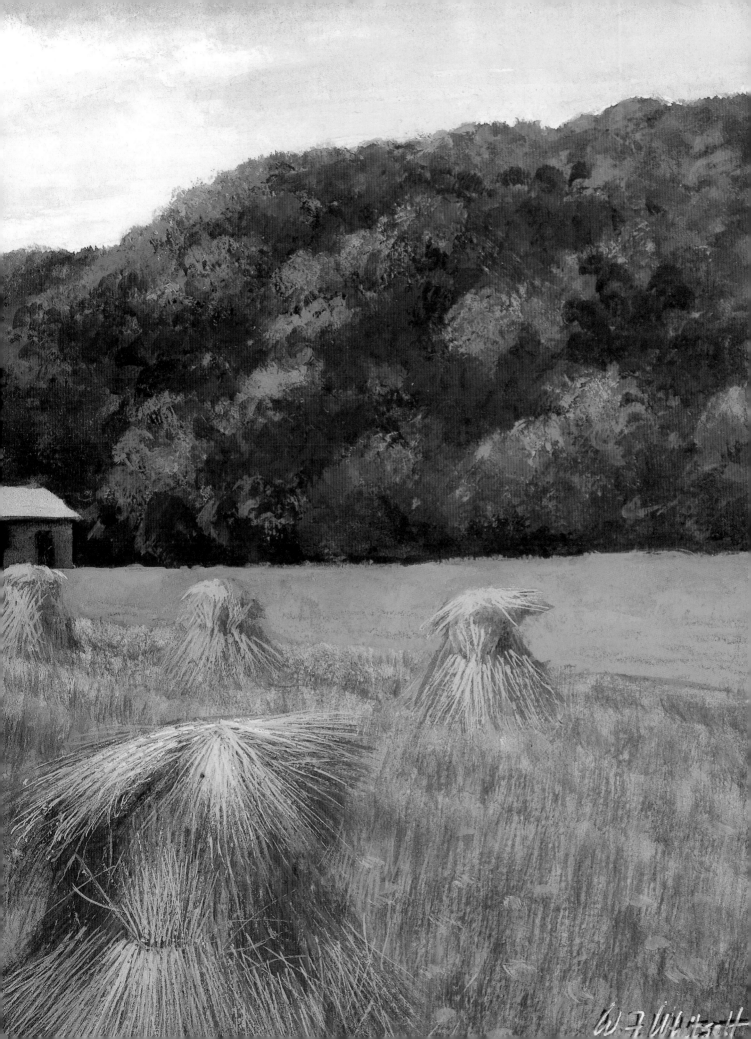

Chapter 3
Still Life

In this chapter, we'll be using a variety of watercolour techniques, including flat, even washes and dryer-into-wet and dry-brush techniques. At times, we'll combine these techniques to illustrate our subject. Often, I find that the subject dictates the approach that should be used. Many students feel it somewhat easier to combine pen and ink with watercolour than to use watercolour on its own.

Here are some quick definitions of the techniques we will be using in this chapter. There are a few new ones, so you might want to look at those a little more closely.

Layering: Each layer of paint must be completely dry before the next layer is applied.

Dryer-into-wet: This technique is a matter of applying more colour into wet colour (but not more water). This technique is also called wet-into-wet.

Dry brush: Paint is applied (with very little water) over the surface of the paper in a way that allows some of the colours or paper underneath to show through.

Softening: To soften an edge, follow these steps. Softening must be done quickly before the painted edge has a chance to dry.
1. Rinse your brush twice in clean water.
2. Take most of the water out of your brush by gently squeezing the brush at the ferrule with a clean, dry tissue.
3. Using a stroke that is parallel to and overlapping the edge you wish to soften, gently remove the still-moist edge of colour. You may need to repeat this procedure several times to soften the edge completely.

Stippling: Gradations in value and hue can be created by using a finely pointed brush to make a series of dots. When stippling, hold the brush vertically (at a 90° angle to the paper). Stippling is an effective way to create the illusion of textures such as sand on a beach or foliage. Stippled textures can also be created by using a sponge as well as other objects. Simply paint the surface of the sponge and press it onto the paper.

Autumn's Fruits

In autumn there is always an exciting explosion of colours. In the following paintings, we will be sampling a few subjects that use these colours.

Apple

This apple was painted using a No. 8 brush and my favourite method of painting with watercolour, which unfortunately is the method students find most difficult to do. It is the dryer-into-wet technique. Timing is all-important with this technique since we will be trying to complete the painting of the apple while the paint is still wet from the first application of water. This means that you must have your paints slightly moist so you can get more on your brush quickly. At no point should you dip back into the water container to rinse your brush or to get more water on it. We are constantly adding more paint to the existing mixture on the brush. This is dryer-into-wet.

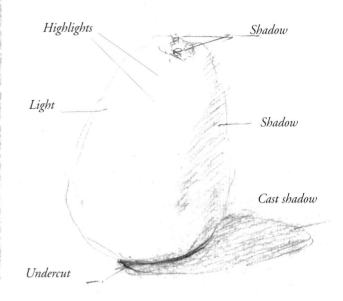

1. Carefully draw the apple (see example above).
2. Wet the whole drawing of the apple except for the small spot of white, which we will call the highlight.
3. Quickly apply a light mixture of cadmium yellow light plus a small amount of Winsor red to the entire apple – except for the highlight (see example, left).
4. Without rinsing your brush, mix more cadmium yellow light and Winsor red into the existing colour in the brush and apply this to the areas that appear more orange in the illustration.
5. Add more Winsor red to your brush and apply this colour to the redder areas.
6. Finally, to make the apple appear round, add a mixture of Winsor red with a small amount of viridian (its complementary colour) to the darker areas of the apple (see example at the top of page 78).

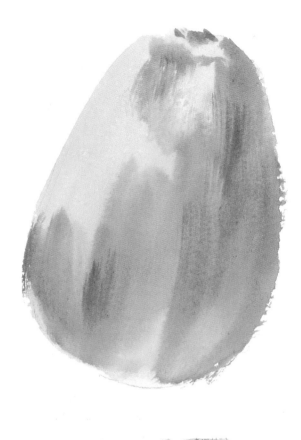

7. Let your painting dry before continuing. We have finished using the dryer-into-wet technique on the apple, so you can also rinse the colour out of your brush now.

8. When the apple is dry, dampen the area of its shadow.

9. Place a wash of Prussian blue to the damp shadow area.

10. Add Payne's grey to your brush (do not rinse) and place this directly under the apple into the blue for the undercut. This should create the illusion of weight.

11. Finally, with your No. 3 brush, paint the stem of the apple (not shown here) with a mixture of viridian and burnt sienna.

Don't be discouraged if your apple didn't turn out perfectly the first time. One very competent student of mine recently had 21 attempts at mastering the dryer-into-wet technique before he was finally successfully on the 22nd. Congratulations John, you showed true grit! (Look in the Student Gallery to see what John has been doing lately.)

Horse Chestnuts
(Aesculus hippocastanum)

The conker, or horse chestnut, also goes by another name in my home state of Ohio – it is called the buckeye, and Ohio is called 'the Buckeye State'.

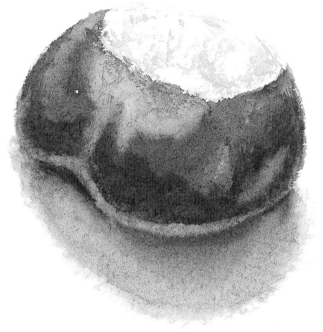

1. Carefully draw the horse chestnut.
2. Mix a very light value of burnt sienna and apply it as a texture to the light 'cap' of the horse chestnut using the No. 3 brush. Let the painting dry before continuing.
3. Wet the rest of the nut with clean water.
4. Paint a light value mixture of Winsor red and burnt sienna on everything except the cap.
5. While the wash is still very wet, mix a darker colour using alizarin crimson, burnt sienna, ultramarine and very little water. Apply this colour into the base colour you painted in Step 4. This is the dryer-into-wet technique.
6. An illusion of a round form can be achieved if this darker mixture is applied again to the right and bottom of the nut. This indicates that there is a light source from above and to the left.
7. When the nut is dry, wet the area under the nut and apply a mixture of ultramarine and Payne's grey to indicate the shadow.
8. To show the weight of the nut, place a darker (and dryer) mixture of ultramarine and Payne's grey directly beneath the nut. Allow the painting to dry before continuing.
9. With your No. 3 brush, dampen a small rim next to the bottom of the conker and press with a tissue to remove some of the dark colour (see above). This suggestion of light reflected from the surface on which the nut is resting helps to create the illusion of form.
10. Repeat Step 9 to achieve the lighter area on the front face of the conker. Also dampen and blot the small reflected lights on the sides of the nut.

Right *A horse chestnut burr.*

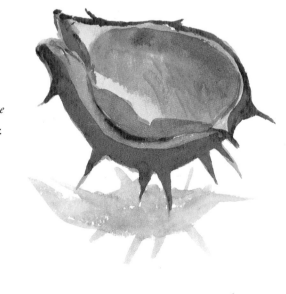

Chinese Lantern
(Physalis)

This plant is grown mostly for the ornamental calyx, which becomes deep yellow, orange and red-orange in autumn. I enjoyed doing this colourful painting. I hope you will too.

1. Try to draw this fragile bit of nature's architecture as accurately as possible. Perhaps the diagram above will help you. The light source is from the left, producing contrast between light and shadow. Note that I used straight lines rather than curved lines to draw this object. This helps to make a more accurate drawing.

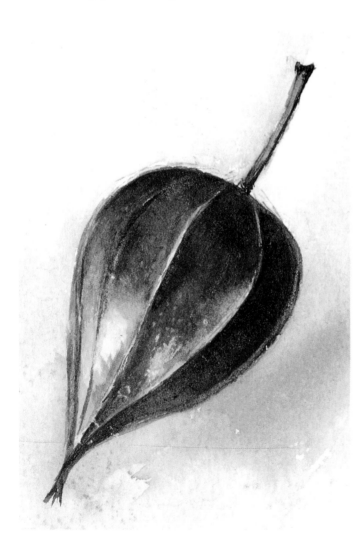

2. Dampen the area around the lantern and paint a small amount of Prussian blue into it using the No. 8 brush.
3. While this area is still damp, paint a slightly stronger Prussian blue into it.
4. After the painting has dried, cover the entire lantern with a wash of cadmium yellow light. Again, let the painting dry completely.
5. Mix cadmium yellow light and alizarin crimson. Use this mixture to paint the segmented sections, using your No. 3 brush, being careful to avoid painting over the yellow ribs. Do one segment at a time and soften each at the bottom with a clean, damp brush. Allow the painting to dry before going on to the next step.

6. With the mixture used in Step 5, repaint the sections, starting at the top of each segment and softening at the bottom. This will strengthen the colour on each segment. Allow the painting to dry.

7. Apply a light wash of Prussian blue to the segment on the right to indicate that it is in shadow. Again, leave the painting to dry. Notice that we are using complementary colours. Prussian blue is a complement of orange. This creates a warm grey. I have discovered that all shadows are some variation of grey.

8. Apply a light wash of Prussian blue over the stem. Let the painting dry.

9. Touch spots of light blue into various areas, as shown in my example.

10. Mix burnt sienna and ultramarine. With great care, accent the ribs and the stem with dark lines in this colour.

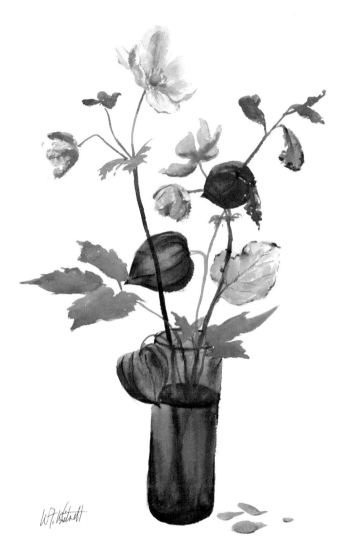

Test each colour mixture on a scrap of paper before using it. The colour you see on your palette may look different on paper. It may look lighter or brighter than you expected, or the mixture may have more of one pigment than you had wanted.

Above *The Chinese lanterns add a contrasting note to the delicacy of the other flowers and leaves.*

Left *It is always good practice to make preliminary sketches before starting to paint.*

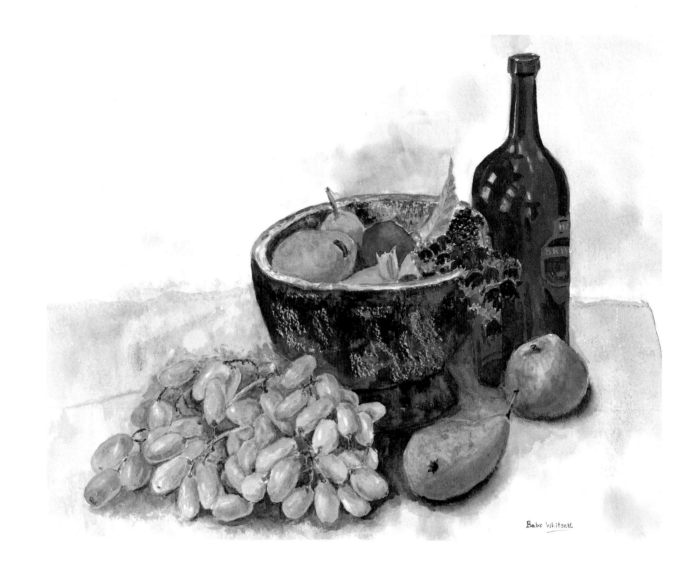

Babs Whitsett

Above *This still life with grapes was painted by my wife, Babs. I like her 'painterly', freer use of watercolour.*

Opposite *Notice that no two leaves are exactly alike – an example of the design principle of 'repetition with variation'.*

Grape

Grapes can add a very light and decorative touch to still-life arrangements. Notice the translucency of the grape. There is no clear-cut division between light and shadow. There is, however, a clear highlight that reflects your light source and a cast shadow that is stronger near the base of the grape. Now that we've made these observations, let's paint!

1. Carefully and lightly draw the grape and stem with an HB pencil.
2. Dampen the area around the grape with your No. 8 brush.
3. Mix Prussian blue and a small amount of Winsor red and apply it to the dampened area behind the grape. Let the painting dry before continuing.
4. Next, dampen the grape except for the highlight.
5. Using your No. 8 brush, mix yellow ochre with a very small amount of Prussian blue and apply it to the dampened area of the grape. Do not paint the highlight.
6. Do not rinse your brush. Add a touch of Winsor red to the colour in your brush and touch it into the right side of the damp grape. This is to add variety to the colour of the grape. Leave to dry.
7. Dampen the area of cast shadow and apply a warm grey mixture of Prussian blue and Winsor red to it.
8. Do not rinse your brush. Add more of the colours used in Step 7 and paint it into the still-damp area of the shadow, directly under the grape. Try to get a soft gradation from dark to light.
9. Apply yellow ochre to the stem.

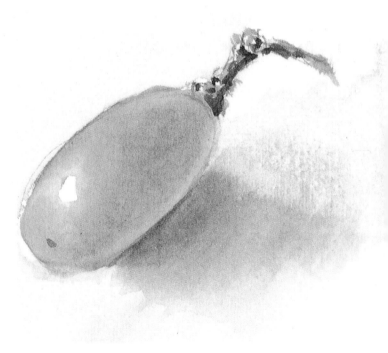

10. When the yellow ochre is dry, touch burnt umber into the right side of the stem.
11. Using your No. 3 brush, dampen the right rim (next to the edge) of the grape and blot with a tissue to create a line of reflected light.

It looks easy but I have a feeling you may need several attempts before you are satisfied with the results – be persistent!

Autumn Leaves

Autumn leaves are often a spectacle of brilliant yellows, reds, oranges and browns. This is true in the northern part of Ohio, my original home, where maple trees abound.

1. Draw the leaf carefully.
2. Apply cadmium yellow light to the entire leaf using the No. 8 brush.
3. While the yellow is damp, apply Winsor red to various sections of the leaf as indicated in my example, using a No. 3 brush. This is the dryer-into-wet technique.
4. Allow the painting to dry before continuing with the next step.
5. Tip the pointed edges of the leaf with a strong Winsor red.
6. After the Winsor red has dried, accent the tips again with burnt sienna. Let the painting dry.
7. Paint the lines of the veins with green created by mixing Prussian blue and cadmium yellow light.
8. Wet the middle vein with water and blot with a tissue. This will make the middle vein lighter.

Below In this windy autumn scene, I have simplified the foreground and placed the strongest contrasts on the trees in the middleground centre of interest.

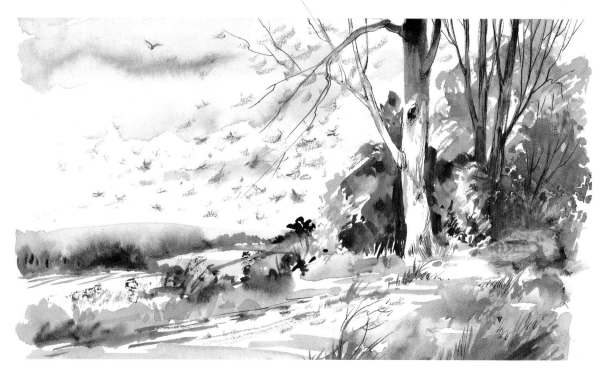

Banana

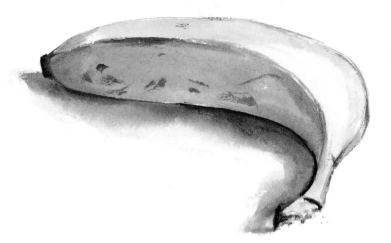

Don't be discouraged if you have difficulty with the softening technique. Most beginners do find this bothersome, but you can master it with some practice. Before beginning, notice that in this example the light is coming from above and behind the right side of the banana.

1. Do a careful drawing of the banana. It is a complex form with subtle foreshortening and difficult contours, so take your time. If you can't draw it, you can't paint it!

2. Create a light yellow mixture using cadmium yellow light with a generous amount of water. Apply it to the top of the banana using the No. 8 brush. Allow the paint to dry.

3. Create the highlight by blotting the damp yellow with a small bit of tissue.

4. Mix a light value of warm grey using yellow ochre, alizarin crimson and Prussian blue. Apply this to the forward-facing side of the banana. This is a light shadow area. Allow the paint to dry before continuing.

5. Mix a darker value of grey-violet using the same colours as above. With clean water, dampen the area under the banana. Then paint the grey-violet mixture in the dampened area.

6. Put more grey-violet pigment on your brush (but no more water) and place this darker grey into the damp area near the bottom of the banana. This will emphasize its weight.

7. Dampen the top of the banana. Make an orange mixture using cadmium yellow light and Winsor red and paint it in the damp area. Before this area begins to dry, rinse your brush, dry it quickly with a soft tissue and soften the yellow-orange paint so there is a smooth transition into the original yellow.

8. Create a light green using cadmium yellow light and Prussian blue. Dampen the area near the stem and apply the green, then soften it.

9. After the painting has dried, dampen the shadow side of the banana. Apply a mixture of green created from cadmium yellow light, yellow ochre and Prussian blue to this shadow area. Soften and let dry before continuing.

10. Mix burnt sienna with ultramarine to create a darker brown. Dampen the brown areas of the banana and paint the textures and accents illustrated in my example. Permit the paint to dry before continuing.

11. Mix an even darker brown using ultramarine and burnt sienna and apply this to the ends of the banana.

12. Use a very light burnt sienna for the light area of the stalk.

Red Pepper

Nature seems to abound with exciting colour relationships – green and red is my favourite. You should have fun with this splash of colour. Have courage – it's not as difficult as you might think.

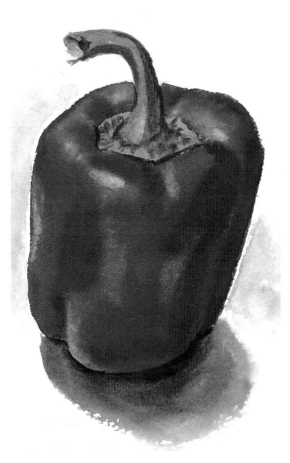

If a colour seems too light, let it dry then apply another wash to make the colour darker. If the colour seems too dark, it is sometimes possible to make it lighter by quickly blotting it with a clean, flat tissue before it dries.

1. Carefully draw the red pepper.
2. Wet the area you will be painting red with clean water. Then, load your No. 8 brush with a mixture of alizarin crimson and Winsor red and apply it into the wet area, letting it spread naturally.
3. Rinse your brush and dry it quickly with a soft tissue. Now, touch the brush into a place in the red area. It will absorb some of the paint from the paper creating a lighter spot for a highlight.
4. Mix more alizarin crimson into the original red mixture. Reload the brush with this darker red and apply it to the shadow side of the pepper.
5. While the paint from Step 4 is still damp, reload the brush with a mixture of alizarin crimson and viridian (the complement) and apply it to the shadow areas of the pepper. Let the painting dry before continuing.
6. Mix cadmium yellow light with Prussian blue and apply this green to the stem. Let the painting dry.
7. Mix alizarin crimson with the green created in Step 6 to create a darker green. Apply this to the shadow side of the stem and to the shadow cast by the pepper.
8. While the cast shadow is still damp, add more alizarin crimson to the green mixture and apply this stronger mixture of green to the cast shadow near the base of the pepper. Allow the paint to dry.
9. Apply cadmium yellow light to the open end of the stem.
10. Dampen the background areas to the left and right of the pepper with clean water.
11. Mix ultramarine with a small amount of alizarin crimson and apply it into the dampened areas.

Above *Note the unity that has been achieved through the overlapping of the elements in this painting.*

Left *Your sketchbook is your friend – use it to catch local scenes, like this Friday market stall in Hadleigh, Suffolk, England.*

Gourd

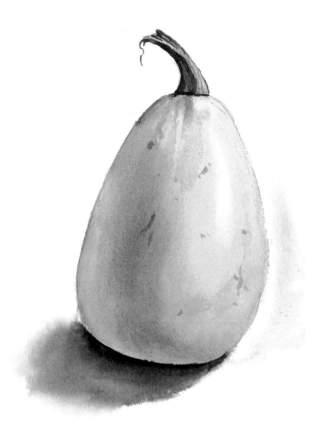

Recently, I met a lady who has a gourd garden. I was amazed at the variety of gourds that she had grown. I hope that this painting of a gourd will help you understand how to make a form appear round. The principles and terminology have been understood and applied since the Renaissance.

1. Mix a very light colour using cadmium yellow light and a small amount of burnt sienna. Apply this to the entire gourd with the No. 8 brush. (You might want to dampen the area first.)
2. Clean and dry your brush, then gently place the dry brush on the gourd where you want to create a highlight. The dry brush will pull colour off the paper. Permit the painting to dry before continuing.
3. Paint a very subtle, light wash of Prussian blue over the right side of the gourd. This is the gourd's halftone.

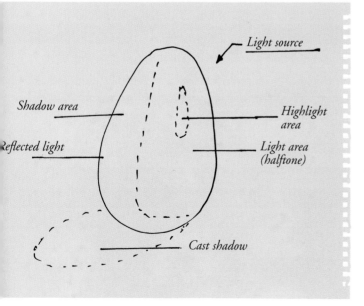

Light source

Shadow area

Highlight area

Reflected light

Light area (halftone)

Cast shadow

Soften the edge with a clean, damp brush.

4. Apply the same colour to the left side and the top of the gourd. Soften the edge with a clean, damp brush. Let the painting dry.
5. Mix a grey using the complementary colours of cadmium yellow light and violet. (Violet can be created by mixing Prussian blue and alizarin crimson.) Apply this grey to the shadow side and bottom of the gourd. Soften and allow the painting to dry.
6. Using a rubber (eraser), lighten the left side (next to the edge) of the gourd to create a reflected light.
7. Paint a light burnt sienna on the stem. Allow the painting to dry.
8. Using burnt sienna mixed with ultramarine, paint the dark, shadow side of the stem.

9. Dampen the area of the cast shadow, then apply a wash of alizarin crimson and Payne's grey to this area. Soften the outer edge of the cast shadow.

10. While the paint is still damp, intrude a darker mixture next to the bottom of the gourd to create the illusion of weight. It will spread into the colour to create a graded wash. (Timing is very important when doing a graded wash – you must not wait long before you put the darker paint into the original colour.) Remember, do not add more water to an area that has started to dry – add more paint, not more water.

11. Dampen an area to the right of the gourd and paint a mix of Prussian blue with a touch of burnt sienna into it.

12. Let the painting dry completely, then dab a few spots of yellow ochre mixed with burnt sienna onto the gourd for texture.

I realize that the technique used to paint the gourd, dryer-into-wet, is difficult for most beginners. Please: try, try and try again!

Below *This painting of gourds is another by my wife, Babs. It is an orchestration of brilliant colours and exciting textures.*

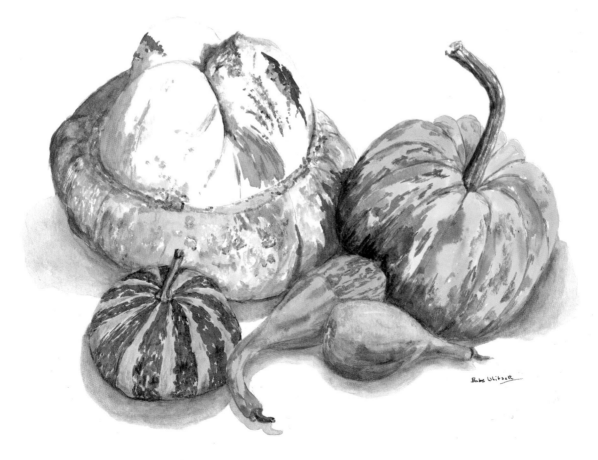

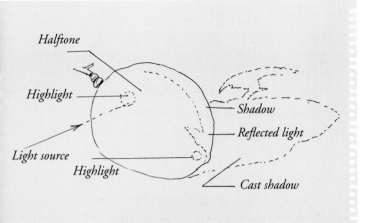

Lemon

We will be using the dryer-into-wet technique to paint the lemon, so timing is very important. As you move from Step 2 to Step 3, work rather quickly so the first wash doesn't dry before you apply the next.

1. Draw the lemon carefully. Try to get the rhythms of the stem and leaf.
2. Wet the lemon with clear water using the No. 8 brush. Then apply a mixture of cadmium yellow light with a small amount of Winsor red to the wet area of the lemon.
3. While this base coat is still wet, apply a mixture of grey to the area of the lemon that is in shadow. This grey colour is made by mixing cadmium yellow light with its complement (Prussian blue mixed with Winsor red). Let the paint dry before continuing.

4. Apply a mixture of cadmium yellow light and Prussian blue to create a green. Apply this green to the stem. Let the painting dry.
5. Create a darker green by mixing cadmium yellow light, Prussian blue and Winsor red. Use this mixture to paint the shadows on the stem. Allow the painting to dry.
6. Add a few touches of Winsor red to the stem.
7. Dampen the leaf and apply the same green colour that was used in Step 4.
8. While the paint in Step 7 is still damp, apply a stronger mixture of green to indicate the veins of the leaf as shown in the illustration. Leave to dry.
9. Using less water, mix burnt sienna and ultramarine, and paint the central vein of the leaf and edge the bottom of the leaf with a fine line. Let the painting dry.
10. Tip your No. 3 brush with clean water and apply to the middle of the vein. Blot this area with a tissue and the vein will be light.
11. Dampen an area to the right of the lemon and create the cast shadow by applying a very light mixture of ultramarine and Winsor red into the dampened area.

Plum

A ripe plum offers us a colour feast of violets, red-violets, blue-violets, blue and black, as well as a variety of greens reflected from the leaves surrounding it. As a plum ripens, surface textures appear – the result of insects and old age.

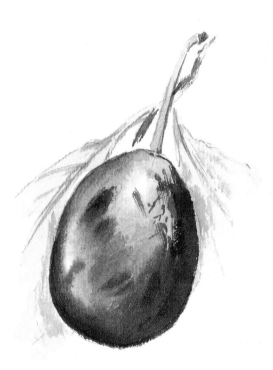

This is the dryer-into-wet technique. Try to avoid mixing too much paint and also avoid an overuse of water. Keep your tissue handy to control the amount of water on the brush.

1. Carefully draw the plum.
2. Dampen the drawing of the plum. Using your No. 3 brush, mix and apply a touch of Prussian blue for the highlight. This blue is a reflection of the sky.
3. Mix and apply a light value of violet (ultramarine and alizarin crimson) to the rest of the plum. This should be applied while the area is still damp. If it is too dry, you should wait until it is completely dry, then dampen it again and continue.
4. Mix and apply a darker mixture of ultramarine and alizarin crimson and apply this into the still-damp perimeter areas to describe the roundness of the plum. Use this same dark colour to show the subtle bruises and deformities on the skin of the plum.
5. Dry and then lightly dampen the above and apply an even darker value (less water and more paint) made with ultramarine, alizarin crimson and Payne's grey.
6. Dampen along the left edge of the plum with a nearly dry number 3 brush. Gently remove some of the existing colour and add a light value of viridian to this area. This will suggest a reflected light.

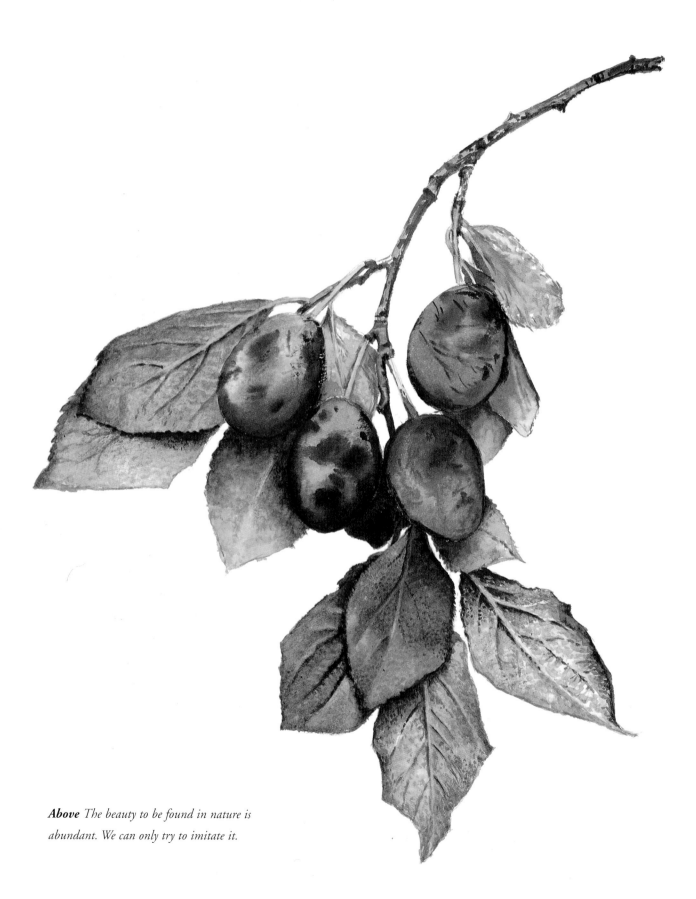

Above *The beauty to be found in nature is abundant. We can only try to imitate it.*

Onion

Onions offer us a variety of subtle and variegated warm colours. It is wrapped in layers of waterproof skin that give protection from weather and insects.

1. Carefully draw the onion, feeling around the form by defining the outlines of the skin with lines (see illustration left).

2. Dip your No. 8 brush in clean water and wet the onion shape. Apply a base coat of cadmium yellow light to all of the skin.

3. While this base coat is still wet, apply a mixture of cadmium yellow light and Winsor red to the moist area.

4. While the paper is still wet, apply a light wash of ultramarine to the shadow side. Allow your painting to dry before continuing.

5. Mix yellow ochre with ultramarine and apply it to the area on the small end of the onion and on the fibrous ends at the top.

6. Mix burnt sienna, ultramarine and Winsor red, and dry brush this on the lower sections to create a rough texture. Leave to dry.

7. With the same colours used in Step 6, use the No. 3 brush to paint the dark linear accents between the sections.

8. Dampen the area under the onion. Move a mixture of alizarin crimson, burnt sienna and ultramarine into the wet area and soften the edge.

9. Place a stronger mixture of the colours used in Step 8 near the base of the onion to suggest its weight.

Pear

A pear is a juicy, delectable sweet fruit with marvellous variations in colour and texture. Each type of pear offers a new challenge to the artist. This is a variety called Bartlett, which was developed in England – delicious!

1. Carefully draw the pear.
2. Dip your No. 8 brush into clean water and wet the pear you have drawn. To this damp area, apply a yellow-green colour that is created by mixing cadmium yellow light with a small amount of Prussian blue.
3. This step should be done while the paint from Step 2 is still damp. With Prussian blue and cadmium yellow light, create a slightly darker mixture of blue-green. Stipple with the No. 3 brush, held vertically, to make the greenish texture.
4. Mix a brown using burnt sienna and ultramarine and stipple this onto the shadow side of the pear as indicated. Also make the scar marks with this colour.
5. Using the same brown, paint the stem. Allow the painting to dry before continuing.
6. With a darker brown (using less water and more paint), paint the shadow side of the stem.
7. Stipple a little Winsor red into the body of the pear as shown in the illustration.
8. Dampen the cast shadow area under the pear. Mix ultramarine, burnt sienna and alizarin crimson and apply it to this dampened area. Soften out with a clean brush at the edges.
9. While the paint in Step 8 is still damp, strengthen the shadow area near the base of the pear to create a graded wash.

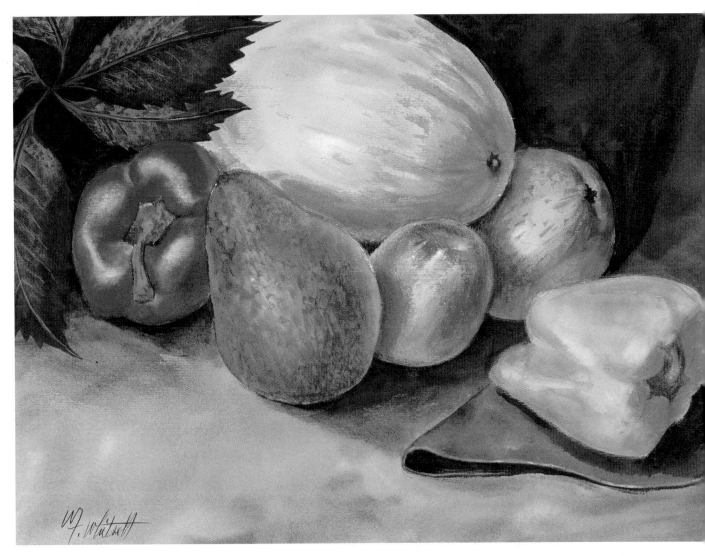

Above *A feast of colour for a still life can be found at your local market. I've shown you how to paint fruit, so give it a try!*

Still-life objects

Many different objects can provide inspiration for still-life paintings – it can be useful to keep a look-out for interesting and attractive shapes as you go about your daily life. Here are two ideas to start you off.

Jug

'Ho, ho, ho! You and me – little brown jug how I love thee!' I remember this jingle from my childhood. The jug is a much-loved favourite for still-life painters. In the process of painting this simple form, we'll review what we have learned about how to make a form appear round.

1. Lightly draw the jug.
2. Mix yellow ochre with a small amount of burnt sienna and apply a light wash to the halftone areas to the left and right of the highlight using the No. 8 brush. Do not put paint on the highlighted areas.
3. While this is still damp, apply the same colour to the far left and to the far right of the halftone areas. Notice that when you cover with the same mixture, the result is darker.
4. Mix burnt sienna with alizarin crimson and a small amount of Prussian blue. Apply this to the area on the right side that is in shadow.
5. Clean and dry your brush on a tissue and gently pull paint from the extreme right where the reflected light will be. The reflected light, although lighter than the rest of the shadow, should not be as light as the halftone area.
6. While this reflected light area is still damp, apply a very small amount of Prussian blue to it.
7. Use the same shadow mixture from Step 4 on the entire top of the jug.
8. Create a shadow on the right side of the top with another layer of the shadow mixture.
9. To make the grey colour for the upper part of the background, mix Prussian blue, burnt sienna and a small amount of alizarin crimson. Apply it freely.
10. Paint the lower background colour with Prussian blue.
11. While the paint from Step 10 is still damp, paint the small suggestion of a cast shadow using a mixture of the complementary colours of burnt sienna and Prussian blue.
12. Accent the jug with dark ink lines using a fine, black permanent ink pen.

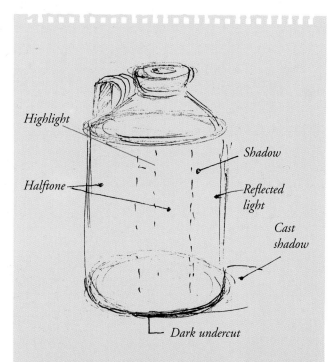

Highlight

Halftone

Shadow

Reflected light

Cast shadow

Dark undercut

Below *Take time to look around and you'll find incredibly interesting subjects to paint. These are pots used by fishermen in Tunisia for catching octopus.*

Seashell

After a long trek along a seashore, I am always amazed at the variety of shells I've found. They come in all shapes and sizes and have an astounding variety of textures and colours. Their curved lines are wonderful. If you use segmented straight lines to draw complex curves, you will be better able to get the shape and proportions correct. See the sketch below.

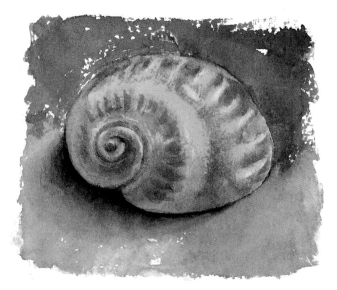

1. Lightly draw the shell.
2. Dampen the entire shell with your No. 8 brush using a light wash of burnt sienna.
3. Pull out the light stripes while the shell is still damp using your nearly dry No. 3 brush.
4. While the first wash is still damp, paint stronger textures of burnt sienna, as shown in my painting.
5. Mix Prussian blue with burnt sienna to create a dark colour. With the No. 3 brush, paint the darker spiral at the face of the shell. Allow the painting to dry before continuing.
6. Next is the area around the shell. Dampen this whole area with the No. 8 brush.

 a) In the foreground area, paint a variegated wash using Prussian blue and a touch of alizarin crimson.

 b) While this area is damp, use the No. 3 brush to apply a mixture of Prussian blue and burnt sienna to create the cast shadow, then soften the shadow with a clean brush.

 c) Using a stronger mixture of Prussian blue and burnt sienna and the No. 3 brush, add a darker value into the shadow area close to the shell to undercut the shell and express weight.

 d) Using the No. 8 brush, mix Prussian blue with burnt sienna and paint this dark grey in the area behind the shell.

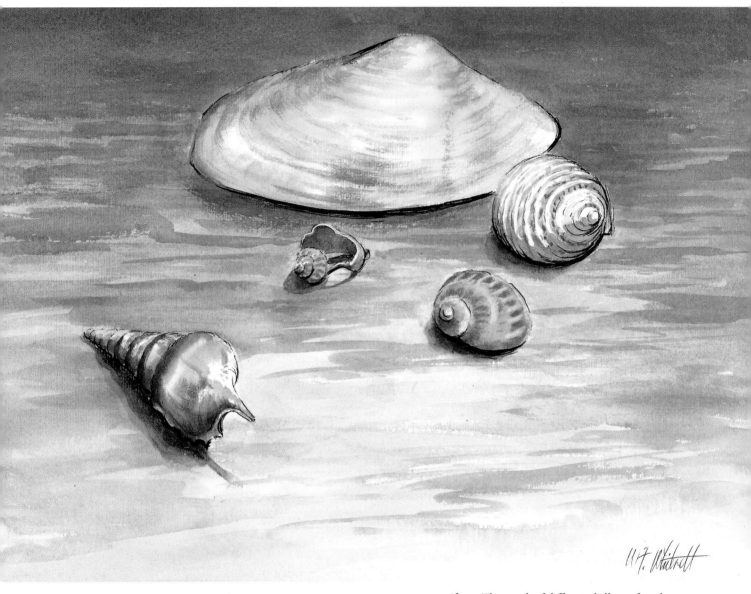

Above *Thousands of different shells are found on
seashores – a challenging subject for any artist.*

Flowers in Bloom

It is my firm belief that your success as a watercolourist is directly related to your drawing skills. If you can't draw it, you can't paint it. The best way to develop your drawing skills is simple: carry a sketchbook with you everywhere and fill it up. Draw daily – anything and everything – but keep drawing! Draw a flower a day if you can and you'll be surprised at how rapidly your drawing skills will develop.

Iris

Each year I pick a flower from our garden and paint a birthday card for my wife. (She's the gardener, although sometimes I cut the lawn.) I love to paint irises because of the luxurious blooms and gorgeous display of colours. They do offer a drawing challenge, so I've picked an 'easy' one for you to do.

Spend a lot of time on the drawing. Draw lightly with an HB pencil so the pencil drawing doesn't put a fence around the flower. Look at the negative shapes (the shapes behind the petals). This should help you get the correct relationship between parts. Now, let's paint an iris!

Petals

1. Lightly and carefully draw the yellow iris on your watercolour paper.
2. Paint a light yellow using cadmium yellow light on all the petals. Allow the painting to dry before continuing.
3. Dampen the area near the top-centre of each petal. Mix a small amount of cadmium yellow light with Winsor red to create a light yellow-orange. Apply this to the dampened areas and soften with a clean, dry No. 3 brush.
4. Repeat Step 3 on the edges of both petals as shown in my illustration.

Leaves and Stems

1. Dampen the stems of the blossoms and drop in a very light mixture of cadmium yellow light and Prussian blue (pale yellow-green).
2. Mix a stronger value of green using cadmium yellow light, yellow ochre and Prussian blue and apply it to the leaves and main stem. Let the painting dry before continuing.
3. Dampen all the leaves and apply a dark value of grey-green created by mixing viridian and alizarin crimson (green and red are complementary colours).
4. Apply the grey-green from Step 3 to the left side of the stem and soften. This will create form and indicate that there is a light source from the right.
5. Paint a darker grey-green line at the division between the stem and leaves.
6. Accent the top of the leaves with a touch of alizarin crimson.

Final Steps

1. Using the point of your No. 3 brush, draw a series of converging fine green lines on the petals as shown in my example.
2. Darken the nearly formed interior male and female parts (stamens and stigma) of the blossom using a light green created by combining cadmium yellow light, yellow ochre and Prussian blue.
3. Add a few final accents of dark brown (burnt umber) and you have completed your first flower in watercolour.

Daffodil

In the spring we welcome the bright display of the daffodils as they bob in the breeze. Perhaps my diagram (right) will be of help when you draw your daffodil. Notice the dotted centre line that moves from the stem out through the hexagonal trumpet. I've used a cylindrical concept of the trumpet to help you see the perspective. Unless the tube of the daffodil is drawn well, the flower will not be convincingly painted. Take your time – get it right!

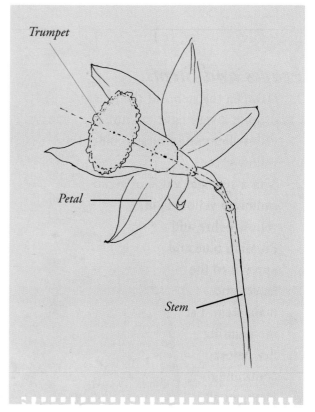

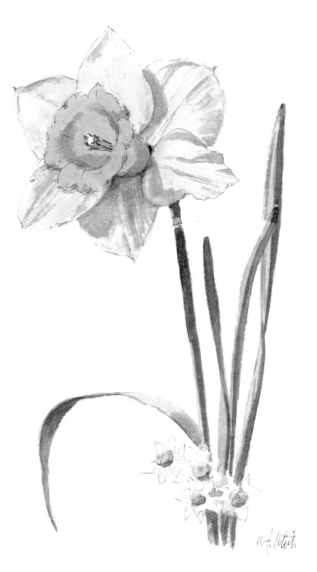

1. With your No. 8 brush, apply a wash of cadmium yellow light over the blossom. Allow the painting to dry before continuing.

2. With your No. 3 brush, paint a light value of viridian on the stem. Allow the painting to dry.

3. With the same brush, paint a light value of burnt sienna on the sepals. Permit drying.

4. Mix the shadows for the blossom using cadmium yellow light and its complement, violet. (Violet is created by mixing ultramarine with alizarin crimson.) Apply this to each of the shadows and soften. Allow it to dry.

5. Mix the shadow colour for the stem using a mix of viridian and alizarin crimson (complementary colours). Apply this to the shadow side of the stem.

6. Accent the sepals and the darker anthers (ends of the stamens) with burnt sienna.

Right I draw with an HB
lead in a mechanical
pencil. I find it easier to
paint flowers if I do
detailed drawings first.

7. Mix a small amount of Prussian blue with
 cadmium yellow light to create a light green
 or a light yellow-green. With the tip of your
 No. 3 brush, paint very thin textural lines
 on the petals.

8. Paint the trumpet with a stronger mixture
 of cadmium yellow light, avoiding the
 pale stigma.

9. Using pen and ink, intermittently accent
 the edges of the leaves and trumpet, as
 indicated in the illustration.

Usually, when pen and ink is used with
watercolour, the pen has a very fine point and
the ink is waterproof.

Rose

Roses are loved by nearly
everyone. They have been an
almost universal symbol of love
and the theme of poets down
through the ages. I drew and
painted this birthday card
on location in Greece. I
didn't have the heart to pick
it so I sat on the ground and
feasted my eyes on its beauty.

It is good practice to do a
preliminary drawing before starting
to paint a flower. It helps you get to
know your subject and prevents
overworking or disturbing your
watercolour paper. Every time you
erase or disturb watercolour paper,
the translucency of the colour is
diminished.

Ready to paint? For most of this
painting, you'll be using a layering
technique and the No. 8 brush.

1. Make a careful drawing of the rose
 with an HB pencil. Don't forget to
 look at the negative shapes to help find
 proportions. Negative shapes are the
 spaces between things.
2. Dampen the blossom and apply a wash of
 cadmium yellow light to the petals. Allow the
 painting to dry before continuing.
3. Mix and apply a light green (cadmium yellow
 light and Prussian blue) wash to the buds and
 stems. Allow the painting to dry.
4. Apply this same light green to the underneath
 portion of the left, front and right sides of the
 blossom. Leave to dry.

5. Apply a lighter value of the green used in Step 4 to the top petals and soften as indicated in my example.

6. Mix a small amount of yellow-orange (cadmium yellow light and Winsor red) and apply a light wash to the middle petal and to the petal to the left of middle. Allow to dry.

7. Apply this same yellow-orange to the underside of the left petal and to the fold above it. Again, allow to dry.

8. Apply this same yellow-orange to the right side of the large central petal (under the middle petal), then soften. Leave to dry.

9. Accent the blossoms with a slightly darker burnt sienna line.

10. Now for the greens on the buds. Lay a light wash of viridian onto the buds, completely covering the wash from Step 3, except for the small light areas of highlight. Once more, leave to dry.

11. Mix viridian with a very small amount of alizarin crimson and apply this grey-green to the left side and underneath each bud. Allow to dry.

12. Accent the divisions of the buds with a slightly darker grey-green.

13. Tip the tops of the buds with a touch of alizarin crimson.

14. Now accent the left side of the main stem with alizarin crimson to show form and indicate the light source.

15. Dampen each remaining part of the stems in sequence and gently drop in viridian and alizarin crimson as shown in my example.

Above *I painted this rose 'on location' so that I didn't have to cut it.*

Chapter 4
Moving On

Now that you have learned the basic
techniques of watercolour painting,
perhaps you are ready to expand your skills and
interests. Here are some hints and tips.

Below *Notice how the mass of distant trees serves
as a balance to the boats on the right.*

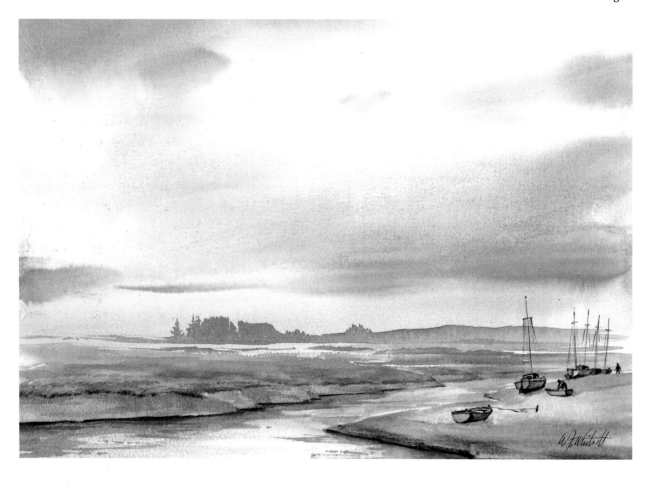

Using Photographs

Most artists today have used photographic references for paintings. The secret to using photographs is 'don't let photographs use you'. So often, I've seen students simply copy photographs and very often the photographs used were of poor quality. Below are a few tips that may help you use them.

1. Be very selective about the photograph you use. Try to find one that provides atmosphere and human interest. We must entertain the viewer of the painting.

2. Having selected the photograph, the next step should be to crop it. See how much of the scene you can eliminate.

3. Now do a preliminary drawing. Juggle things around until you find a pleasing arrangement.

4. Eliminate anything that does not help tell your story.

5. Now apply the rules of composition and the principles of design to arrive at a value sketch. This pre-thinking should help you do a more direct and spontaneous watercolour. (Refer to 'Rules of Composition' and 'Design It!' below.)

6. Finally, nature is your best friend and teacher. Draw and paint on location as often as possible and use your photographs for details.

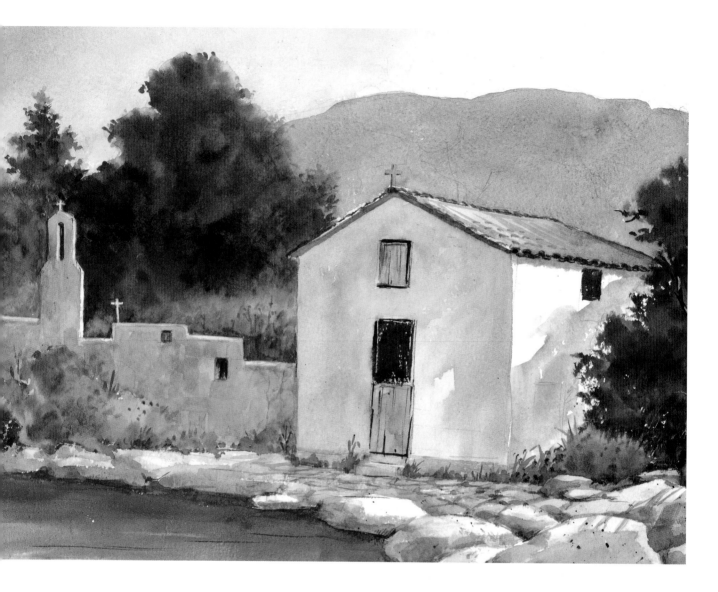

Right and above *Parga Harbour, Greece.*
Can you see how I've applied design principles
to the photograph to make the painting?

Rules of Composition

Composition has to do with the organization of all the elements in your scene to make an effective painting. I've listed a few ideas that might help you.

1. Place your centre of interest so it is above or below – and to the right or to the left of – the centre of your painting. This is what is called an aesthetic centre of interest (an idea of ancient Greek origin).
2. Avoid lines that carry the viewer's eye straight out of the picture.
3. Try to provide the viewer with a 'path' into the picture. This is called a 'lead-in'.
4. Place the horizon so that it does not cut the picture in half. Try to have a foreground, a middle ground and a background to help create the illusion of depth and space.
5. Keep the foreground simple so the viewer is not blocked out.
6. Apply the principles of atmospheric (also called aerial) perspective. These principles include:
 • Values get lighter as objects recede
 • Colours in space become greyer with distance
 • Edges tend to soften with recession
 • Forms become less textured and flatter with recession

Take time to study nature and prove the validity of the above ideas.

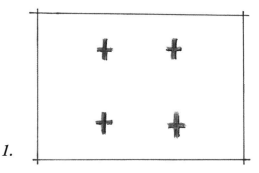

1.

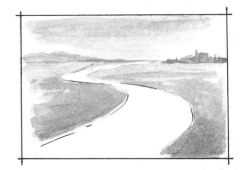

2.

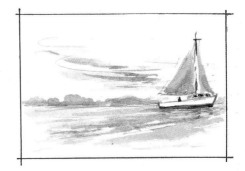

3.

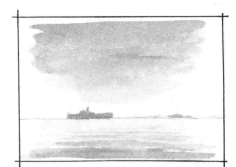

4.

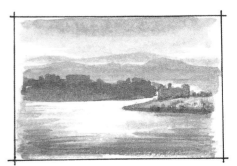

5.

Design It!

Designing your own painting may seem a bit overwhelming – but don't let it intimidate you. All you really need to do is follow a few basic principles of design.

1. Balance – provides a sense of order and stability to a painting.
2. Repetition with variation – creates harmony and interest.
3. Contrast – avoids monotony. We see all things because of contrast:
 • Dark versus light
 • Rough versus smooth
 • Large versus small
 • Bright versus dull
4. Gradation – a gradual change in size, colour, value or brilliance. Gradation tends to add interest to any area.
5. Emphasis and subordination – helps you express your idea. With this principle, you find ways to emphasize some elements and to de-emphasize (make subordinate) others. Most emphasis should be at the centre of interest. This can be achieved by placing the following there:
 • The greatest contrast in value (for example by using dark versus light)
 • The brightest colour contrast (bright versus dull)
 • The human interest (people, animals or man-made objects)

Rules of composition can be broken, but principles of design should be applied as often as possible in the development of your painting.

1.

2.

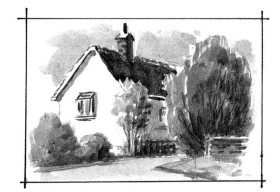

3.

4.

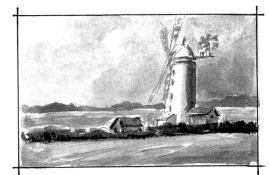

5.

Above *A quince branch from our garden offered me inspiration for this painting. I have applied the design principle of 'repetition with variation' to the painting of the leaves as well as the quinces.*

Right *Have you ever attempted to paint a completely non-objective abstraction? It's not as easy as it looks. You must apply all your design principles if you are to be successful.*

Figures

When figures or animals are in landscapes, they seem to say 'hello' to the viewer because they attract the viewer's attention. They can do much to add interest to your compositions – but only if they are drawn well. Here are a few tips that might help you.

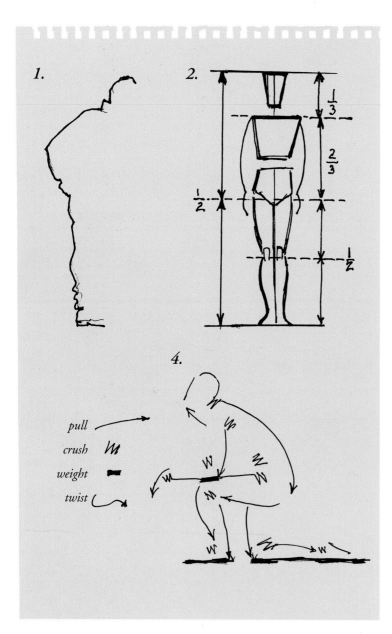

1. The 'one-lines' will help you avoid the problem that occurs when the figure you are trying to draw suddenly moves. Try to do a simple, quick line drawing of one side of the figure. You can usually add the rest later.

2. Here is a diagram that could help you get normal proportions in your figures.

3. The gesture (movement or tendency towards movement) is very important. You can make your own wire mannequin figure and put it into action.

4. My illustration analysing the forces at work – pull, crush, weight and twist – in a human figure may help you get convincing gesture in your drawings.

Always carry a sketchbook and use it whenever possible.
There isn't a better way to learn figure drawing than this. I've been using sketchpads for most of my adult life.

Student Gallery

*I*t's a teacher's dream to have students who are highly motivated, intelligent, full of fun, gifted and truly pleasant company – and this is what I have been blessed with since becoming an art teacher in 1948. I would happily be an art teacher again if I had it to do over. My way of thanking my students for the pleasure they have given me is to show some of their efforts in this student gallery (with apologies to the students whose paintings are not shown here).

It has been my privilege to have been able to find happiness and fulfilment in the company of all of you wonderful students. It has always been a learning process for me – you have all taught me a great deal. You have been my very best teachers. I have witnessed your courage, your successes, your failures, your struggle to make something worthwhile out of coloured mud on paper and canvas and, as a result, you have educated me. I now realize that it is your true grit, not my instruction, which has made you all excellent artists. I have only planted a few seeds and watered the soil; you are the ones who have grown.

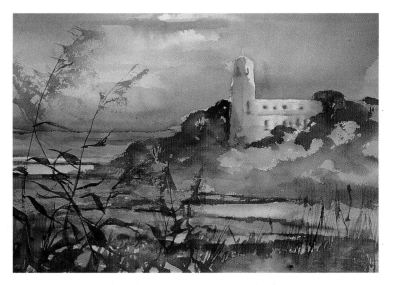

Left *The grasses in the foreground help to create the illusion of space in this painting by Elizabeth Gardiner.*

Right *The artist who painted this rural scene, Arthur Essex, is 92 years old.*

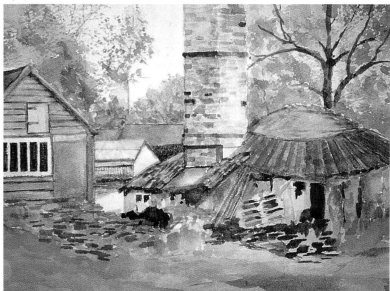

Left *The planks in the foreground of this painting by Dr. Ruth Nainby-Luxmoore lead the eye of the viewer into the painting.*

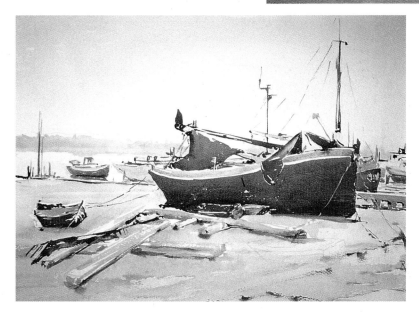

Right *The fowl in the foreground of Joan Gatward Bailey's composition create a centre of interest.*

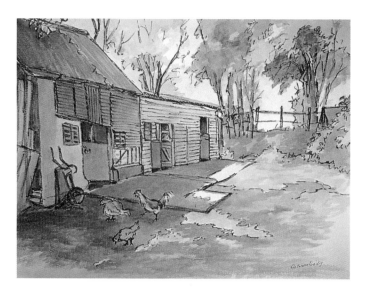

Left *The strong foreground silhouettes contrast dramatically against the distant landmasses in this painting by Margaret Laws.*

Right *Evening shadows breaking across the foreground field help suggest this sunset scene by Jacqueline Green.*

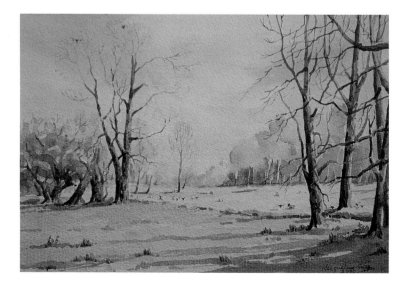

Left Anything can be beautiful if one has the imagination to make it so, as proved in John Heywood's painting.

Right The white snow provides a strong horizontal contrast to the dignity suggested by the the verticals of the church and trees in this painting by Dr. Francesca Chianci.

Left Diana Glanfield's painting is an excellent example of the principle of repetition with variation.

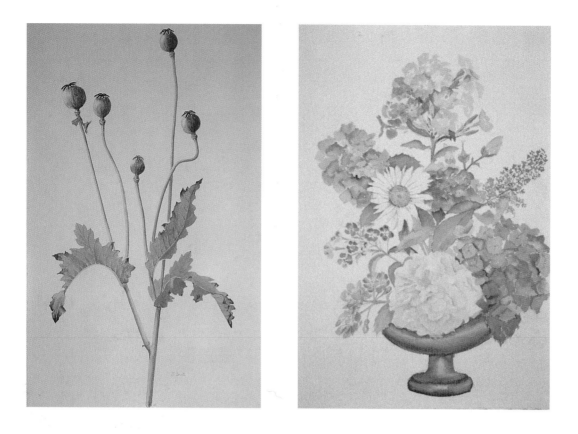

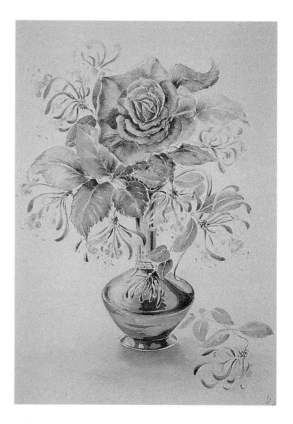

Above left *An almost Oriental feeling of restraint gives dignity to a humble subject in this flower study by Lady Susan Smith.*

Above right *At the age of 93, Ethel Payne continues to find joy in painting flowers.*

Right *This rose truly says 'hello' to the viewer. Marilyn Groves has dared to centre it and has made it work!*

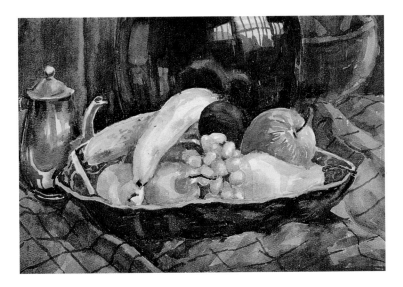

Left Ann Jones has succeeded in painting a challenging subject with a variety of textures and contrast.

Right Eileen Duell has produced a complex composition, using subtly overlapping man-made elements.

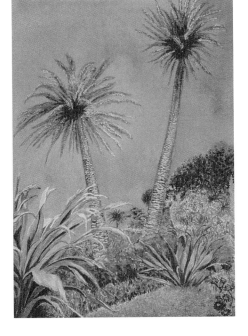

Left The radiating palms and plants suggest a gentle swaying movement in Dr. June MacGregor's painting.

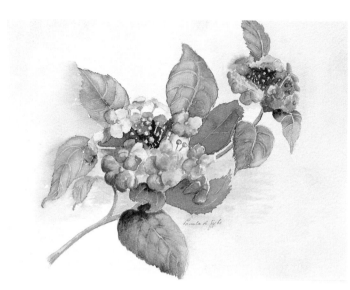

Left *Notice the variety of greens Pam Gyte has used in this painting.*

Right *Carey Foster has controlled the single light source well to create this illusion of three-dimensional form.*

Left *I received a phone call from Chris Langdon: 'Guess what, Bill, I got the painting of the steam engine into the Royal Academy Summer Show!'*

Right *Beth Halasz is a professional medical illustrator, here working in watercolour.*

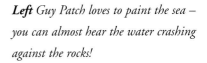

Left *Guy Patch loves to paint the sea – you can almost hear the water crashing against the rocks!*

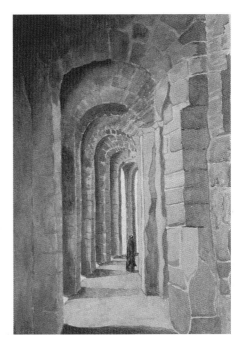

Right *Zachary Taylor is an expert musician turned painter. The small figure in this painting gives a sense of scale to the architecture.*

Right *Michael Chapman is now 90 years old, is colourblind, walks with two canes and still outpaints most of my students.*

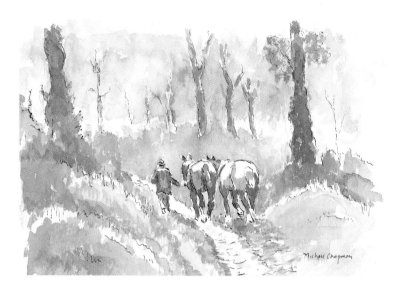

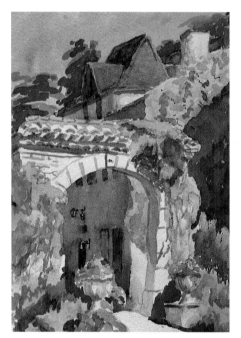

Left *Notice how the use of complementary warm and cool colours has created a lively mood in this painting by Janet Boreham.*

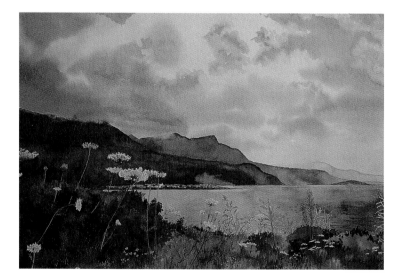

Right *Tony Flintham's painting has been unified by a saturation of warm colours.*

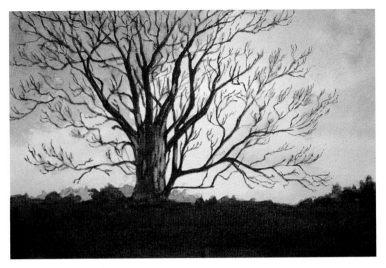

Left *Mary Fotheringham's love of trees is expressed in this strong silhouette.*

Right *Betty Rowley's penetrating eye means she is successful when painting even the most complex subjects.*

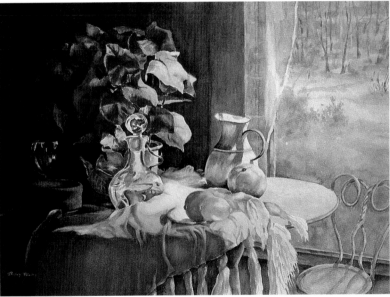

Left *Michael Deibel is a professional pilot as well as a professional painter.*

Final Words

These words of wisdom have been gleaned from many sources through the years.

- Remember that every great artist was once a beginner.
- Have an inspired idea – or take a walk.
- True grit is the essential quality necessary to develop competence in watercolour painting.
- Bad paintings come out of the gristmill of every good artist.
- Don't be afraid to waste some watercolour paper.
- Choose a subject that others might pass by.
- If you can't draw it, you probably can't paint it.
- Art is anything well done.
- Happiness is moving towards a receding objective.
- 'Painting is another word for feeling' (John Constable).
- The way to learn to draw is: draw, draw, draw!
- Every square inch of your painting should entertain the viewer.
- Simplify!
- Eliminate everything that is not essential to expressing your idea.
- Painting is not just about painting what you see – it is also painting what you wish to see.
- Many look – but don't see.
- Examine the negative shapes if you wish to see the positive shapes of an object or colour.
- 'It is a sorry thing when the theory outstrips performance' (Leonardo da Vinci).
- The first two or three hundred watercolours are usually the most difficult.
- Your completed painting should look as though it was done effortlessly.
- Some artists paint things. True artists also express what they feel about things.
- Know the principles of design and apply them.
- Habitually start with a preliminary sketch.
- Use a larger brush than you think you can handle.
- Simplify your palette. Most colours can be made by mixing combinations of red, yellow, blue and black.
- Painters belong to a great community in which there are no strangers.
- If the composition is poor, the painting will never look right no matter how well executed.
- A painting approached without passion is a kiss without love.

Bibliography

Barlow, Jeremy. *North Norfolk landscapes.* Jeremy Barlow Publications, 1985.

Bellamy, David. *Painting in the wild.* Webb-Bower, 1988.

Chamberlain, Trevor. *Light and atmosphere.* David and Charles, 1999.

Couch, Tony. *Tony Couch's keys to successful painting.* North Light Books, 1992.

Couch, Tony. *Watercolor: you can do it.* North Light Books, 1986.

Curtis, David. *The landscape in watercolour.* David and Charles, 1996.

Edwards, Betty. *Drawing on the right side of the brain.* J P Tarcher, 1979.

Beningfield, Gordon. *Beningfield's English landscape.* Viking, 1985.

Fletcher-Watson, James. *The magic of watercolour.* Batsford, 1987.

Franck, Frederick. *The Zen of seeing.* Wild Wood House, 1973.

Goldstein, Nathan. *The art of responsive drawing.* Prentice Hall, 1973.

Henri, Robert. *The art spirit.* Lippencott, 1960.

Hilder, Rowland. *Painting landscapes in watercolour.* Watson-Guptill, 1983.

Hilder, Rowland. *Starting with watercolour.* Watson-Guptill, 1966.

Hilder, Rowland. *Successful watercolour painting.* Collins, 1986.

Kautzky, Ted. *Ways with watercolor.* Reinhold Co., 1963.

Merriott, Jack. *Discovering watercolour.* Pitman, Watson-Guptill, 1973.

Pike, John. *Watercolor.* Watson-Guptill, 1966.

Ranson, Ron. *Big brush watercolour.* David and Charles, 1989.

Ranson, Ron, *Edward Seago.* David and Charles, 1981.

Ranson, Ron. *Learn watercolor the Edgar Whitney way.* North Light Books, 1994.

Ranson, Ron. *Watercolour fast and loose.* David and Charles, 1987.

Ranson, Ron. *Watercolour Impressionists.* David and Charles, 1989.

Richmond, Leonard and Littlejohns, J. *Fundamentals of watercolor painting.* Watson-Guptill, 1978.

Simpson, Ian. *Landscape painting.* Collins, 1990.

Smith, Ray Campbell. *Ray Campbell Smith's way with watercolour.* David and Charles, 1997.

Soan, Hazel. *What shall I paint?* Collins, 2002.

Thatcher, Bryan A. *Wet-into-wet.* Search Press, 1995.

Wesson, Edward. *My corner of the field.* Alexander Gallery, 1982.

Left The elements are scaled from large to small in this typically English village scene, giving the illusion of deep space.

Below The sky is the most important element of most landscapes, in that it expresses the atmosphere of that specific day.

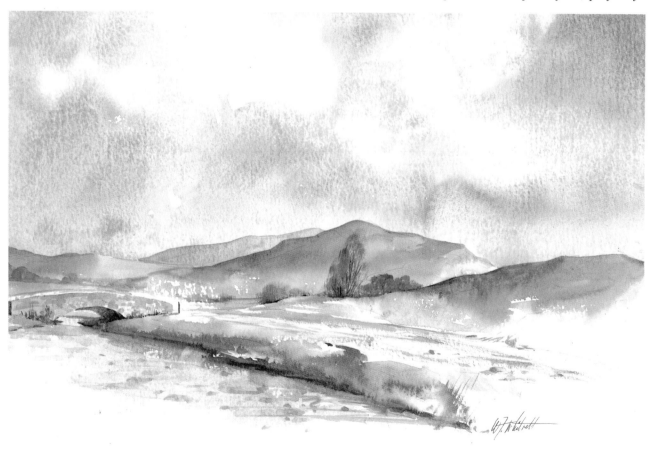

Index

Figures in italics indicate captions; those in bold indicate a main reference.

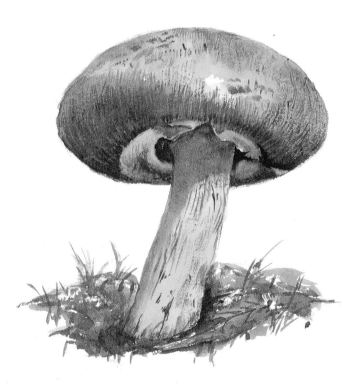